BIG CATS

A PORTRAIT OF THE ANIMAL WORLD

Andrew Cleave

SMITHMARK

This edition published by SMITHMARK Publishers Inc.,
16 East 32nd Street, New York, NY 10016

SMITHMARK books are available for bulk purchase
for sales promotion and premium use.
For details write or call the manager of special sales,
SMITHMARK Publishers Inc.,
16 East 32nd Street, New York, NY 10016; (212) 532-6600.

This book was designed and produced by
Todtri Productions Limited
P.O. Box 20058
New York, NY 10023-1482
Fax: (212) 279-1241

Printed and bound in Singapore

ISBN 0-8317-0873-5

Author: Andrew Cleave

Producer: Robert M. Tod
Book Designer: Mark Weinberg
Photo editor: Edward Douglas
Editors: Don Kennison, Shawna Kimber
Production Co-ordinator: Heather Weigel
DTP Associate: Jackie Skyroczky
Typesetting: Command-O, NYC

Printed and bound in Singapore by Tien Wah Press

PHOTO CREDITS

Photographer/Page Number

Aquila Photographics
Hanne & Jens Eriksen 43
Mike Lane 48
M. C. Wilkes 59

Peter Arnold
Y. Arthur-Bertrand 19 (bottom)
S. Asad 27 (top)
C. & M. Denis-Huot 8-9, 51, 54 (bottom), 55
Gerard Lacz 20 (top & bottom)
Luiz C. Marigo 36
Fritz Polking 12 (bottom), 50 (top)
Roland Seitre 24-25
Guenter Ziesler 27 (bottom), 49 (top), 57 (top right), 57 (bottom right)

Dembinsky Photo Associates
Mike Barlow 16
Dominique Braud 77
Stan Osolinski 15 (top)
Fritz Polking 30, 50 (bottom), 52, 56-57
Mark J. Thomas 42, 47

Jeanne Drake 26, 28 (top), 31 (top & bottom), 32 (top & bottom), 33, 60, 68, 69 (bottom), 76

Ron Kimball 10, 21, 34, 35, 74

Joe McDonald 4, 13, 18, 38, 45, 46, 49 (bottom), 58 (top), 63 (bottom), 64 (top & bottom), 66, 71, 72-72

Mary Ann McDonald 17, 19 (top)

Nature Photographers Ltd.
P. Craig-Cooper 44(bottom)
R. S. Daniell 53 (top)

Picture Perfect USA
Fritz Polking 53 (bottom)

Len Rue, Jr. 75 (top & bottom)

Leonard Lee Rue III 14, 58 (bottom), 69 (top)

Tom Stack & Associates
Nancy Adams 28 (bottom)
Rod Allin 63 (top)
Jeff Foott 6
Warren Garst 12 (top & middle), 39 (top & bottom)
Victoria Hurst 7
Tom Kitchin 65
Joe McDonald 62 (top)
Brian Parker 67
Robert Winslow 23, 61

Wildlife Collection
D. Robert Franz 70, 78
Lorri Franz 79
John Giustina 11, 22, 29, 44(top), 54 (top)
Martin Harvey 3
Henry Holdsworth 62 (bottom)
Tim Laman 5
Jack Swenson 15 (bottom), 37, 40-41

INTRODUCTION

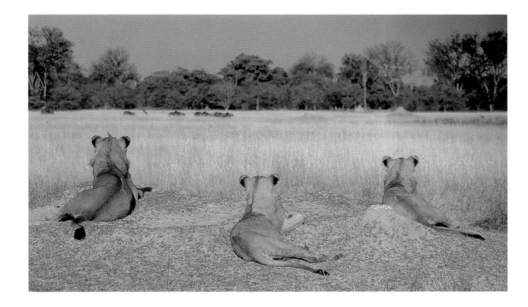

A pride of lionesses contemplates a possible meal as they study a small herd of wildebeest grazing peacefully on the East African savannah. If they consider their chances of success high they will attack, but if the prey is too distant or too alert the lions will save their energy for an easier kill.

The grasslands of East Africa seem to stretch forever toward the horizon. Late in the afternoon, when the hot equatorial sun is losing some of its intensity and the shadows are lengthening, herds of wildebeest and small groups of zebra become a little restless. Tossing heads and swishing tails show that something is unsettling them.

Just visible in the parched grass near the grazing herds are two rounded ears; a lioness lies still, awaiting the moment to lead an attack on whichever animal shows some signs of weakness. A female with a newborn calf or an injured adult, one which has strayed a little too far from the herd, may be singled out as the prey.

The lioness will not be alone. Somewhere nearby are two or three of her relatives, sisters and daughters, perhaps, who will await her signal before encircling the chosen prey. Creeping silently, tails down and bodies almost scraping the ground, the lionesses move forward bit by bit until the moment is judged to be right for the attack. Then with a sudden burst of speed they charge out of the long grass, powerful hind legs propelling them after the startled prey.

The prey animal will have little chance of escape with lionesses on every flank, and one soon overpowers it, leaping onto it

3

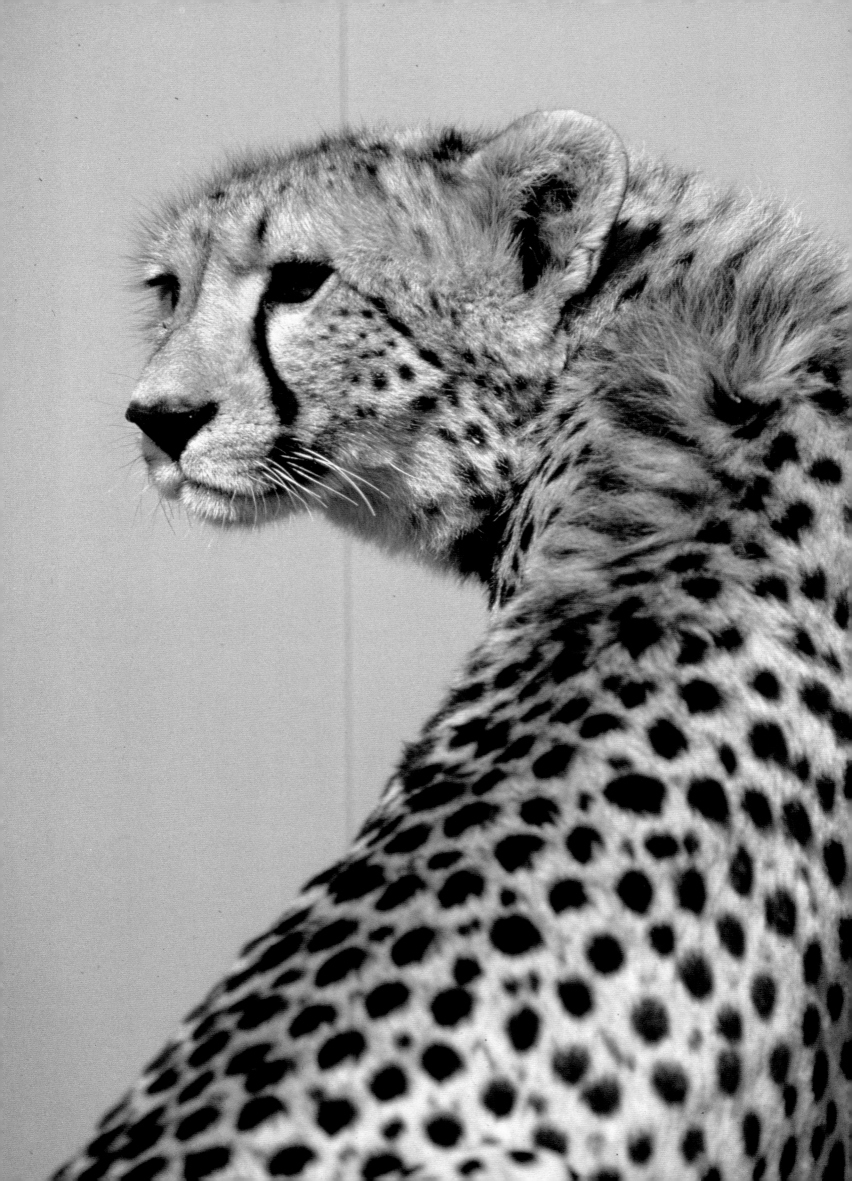

from behind, its sharp claws and strong teeth biting into flesh. The sheer weight and power of the predator are enough to knock the prey down, and once on the ground it will be killed by a powerful suffocating bite to the throat. The other lionesses are soon upon it, and once rested they will begin to tear into the flesh.

Their feast may not last long, however, as a big male lion, who will have watched the hunt from a safe distance, now pushes in to eat his fill, driving the females away. Only when he is satisfied will the lionesses be able to reclaim their hard-won meal.

Soon peace will return to the plains, and the herds of grazing animals resume their feeding as if nothing happened. Vultures, hyenas, and jackals make short work of what little remains of the carcase. The lions will have played their part in the maintenance of life on the African plains; by singling out weak or sick animals the predators help to retain healthy populations of grazers. The delicate balance of life on the plains continues. These superb hunters are as important to the well-being of their prey as the prey animals are to them.

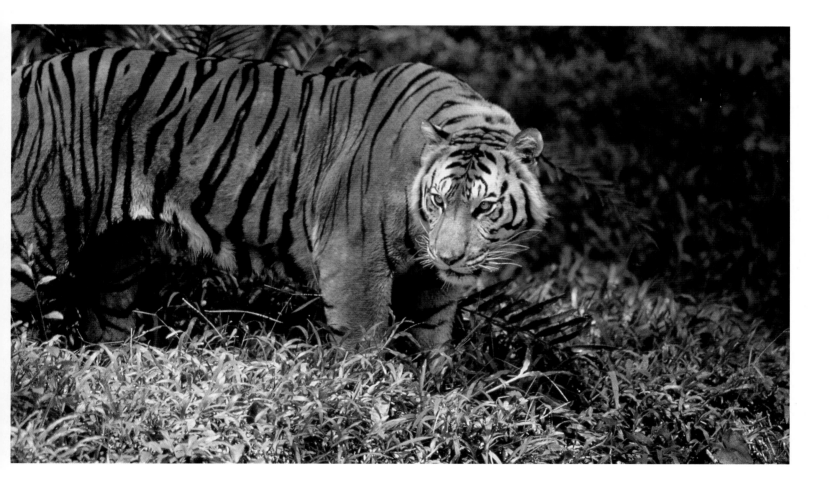

Renowned as one of the fastest of all land mammals, the cheetah is the swiftest and most agile of the big cats, capable of bursts of speed that can outpace a gazelle.

One of the world's most feared predators is the tiger; stealth, speed, power, and fearsome claws and teeth combine to make this Sumatran tiger a supreme hunter.

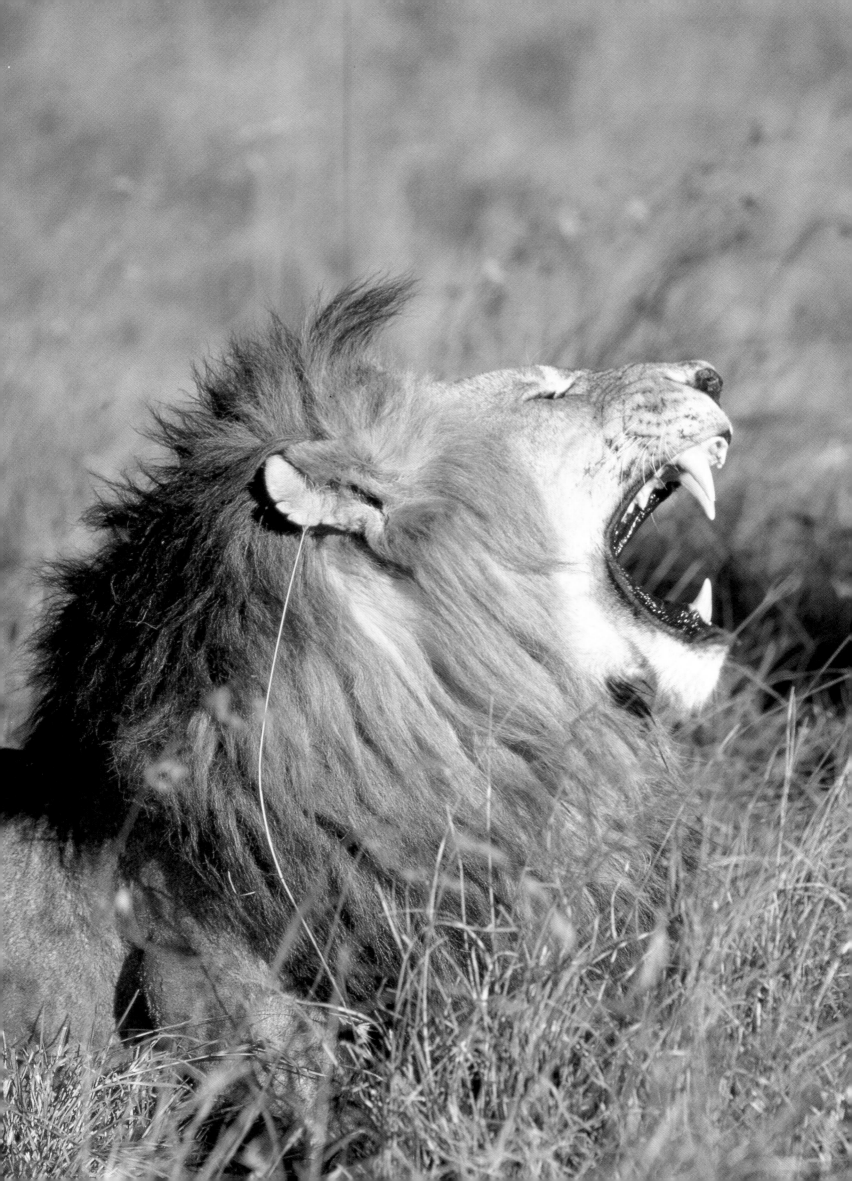

THE NATURE OF CATS

Cat Claws

Even the most placid and friendly domesticated pet cat will bring to mind the cat family's sharp and powerful claws, which can be put to deadly use if necessary. Of a cat's impressive armoury of weapons, from which it can draw to help capture and kill its prey, the sharp retractable claws are the most characteristic.

The claws may be hidden for much of the time in misleadingly soft paws, but when extended, their sharp, curved points and great strength declare that any creature within their grip will be fatally trapped. They can be retracted into sheaths when not in use so that they remain sharp and ready for action; occasionally cats will sharpen up their claws by scratching them on posts or tree trunks. Only the fast-running cheetah is unable to fully retract its claws.

All cats have thick hair around the pads of their feet, which allows them to stalk their prey silently. Cats walk on their toes, enabling them to be quiet but also to run fast if necessary.

Teeth

Second only to the sharp claws are the cat's teeth. Even in the smallest cat species they are needle-sharp and very strong; in the big cats they are fearsome, especially if displayed within the open mouth of a roaring animal. Coupled with the large masseter or cheek muscles, the teeth give an exceedingly strong grip that can hold large prey tight until dead.

The jaws are short, and hinged in such a way that the bite can only come in one direction—up and down. This is ideal for shearing through tough meat and even bones, and the specially adapted carnassial teeth, or rear molars, are strong enough to cut through sinewy flesh and thick skin and hides. A cat's tongue is covered with numerous sharp lumps, or papillae, which help improve the grip and are used when the cat rasps away small pieces of flesh after a kill.

Following page: At nearly four months old a cheetah is growing to be almost as large as its mother. Its teeth are becoming large and strong, but it still must depend on its mother to catch its food as it has yet to acquire the strength and speed to capture its own prey.

A North American mountain lion, or puma, stretches out on a branch, showing the full extent of its large paws with their retractable claws.

A thick-maned male lion yawns in the afternoon sun, showing off his magnificent set of teeth. Like all cats, lions have short but immensely powerful jaws, which are capable of a strong, crushing bite.

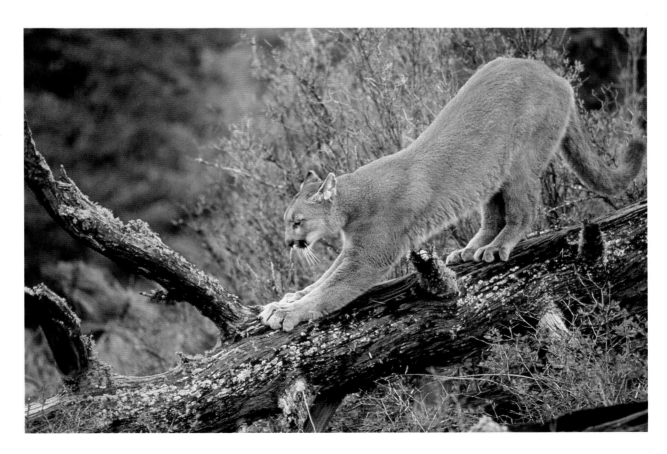

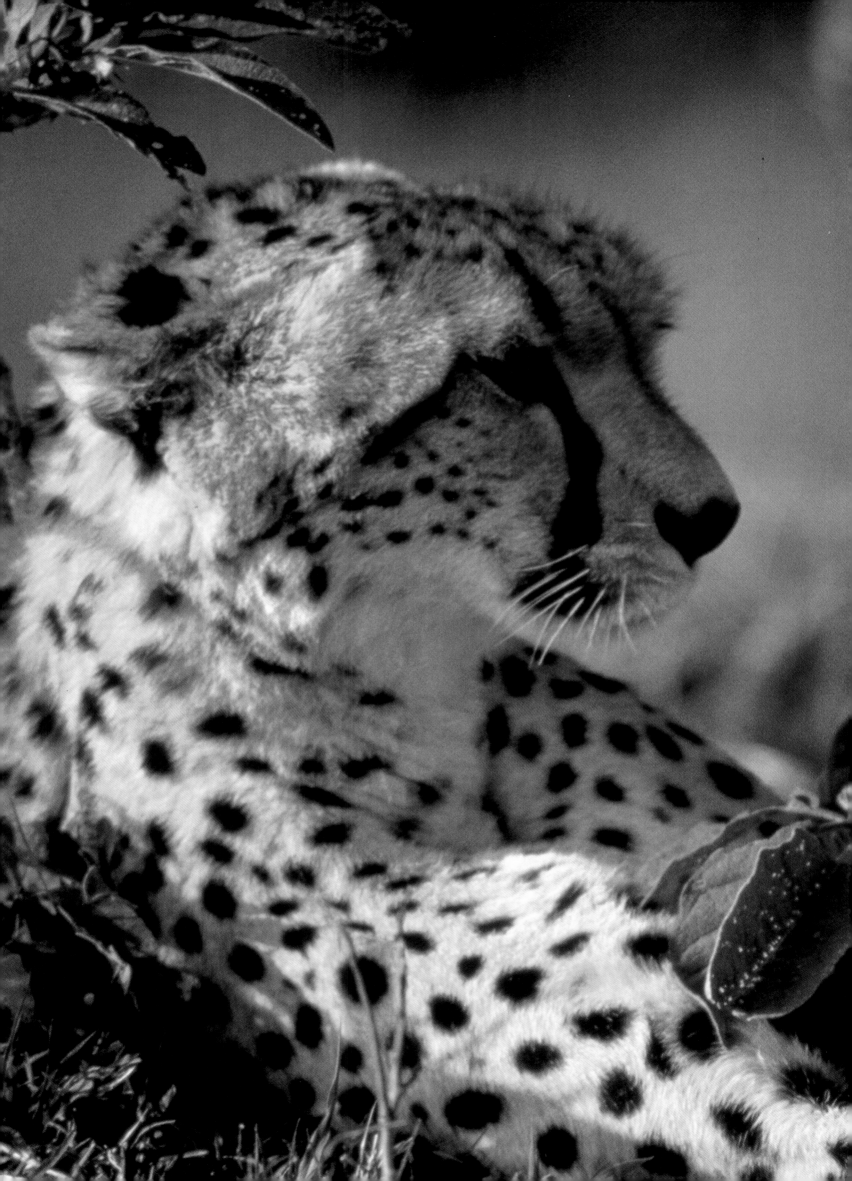

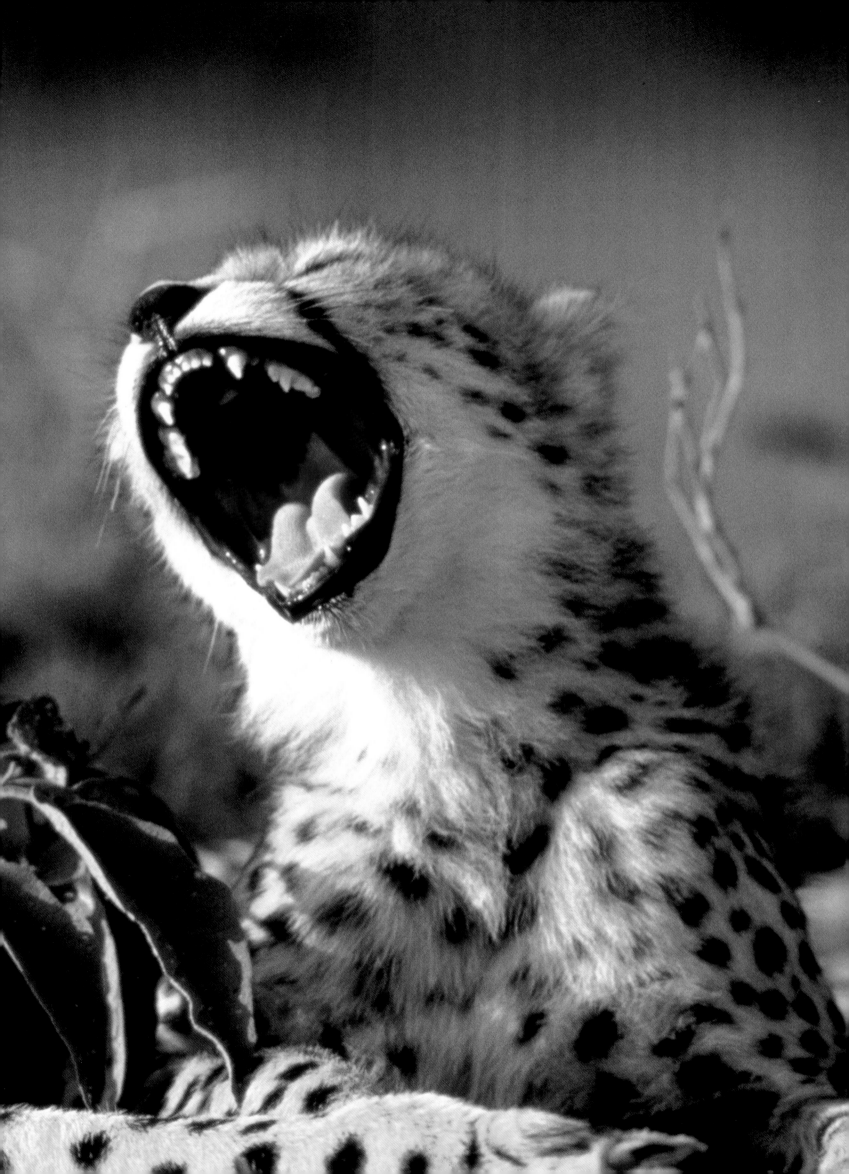

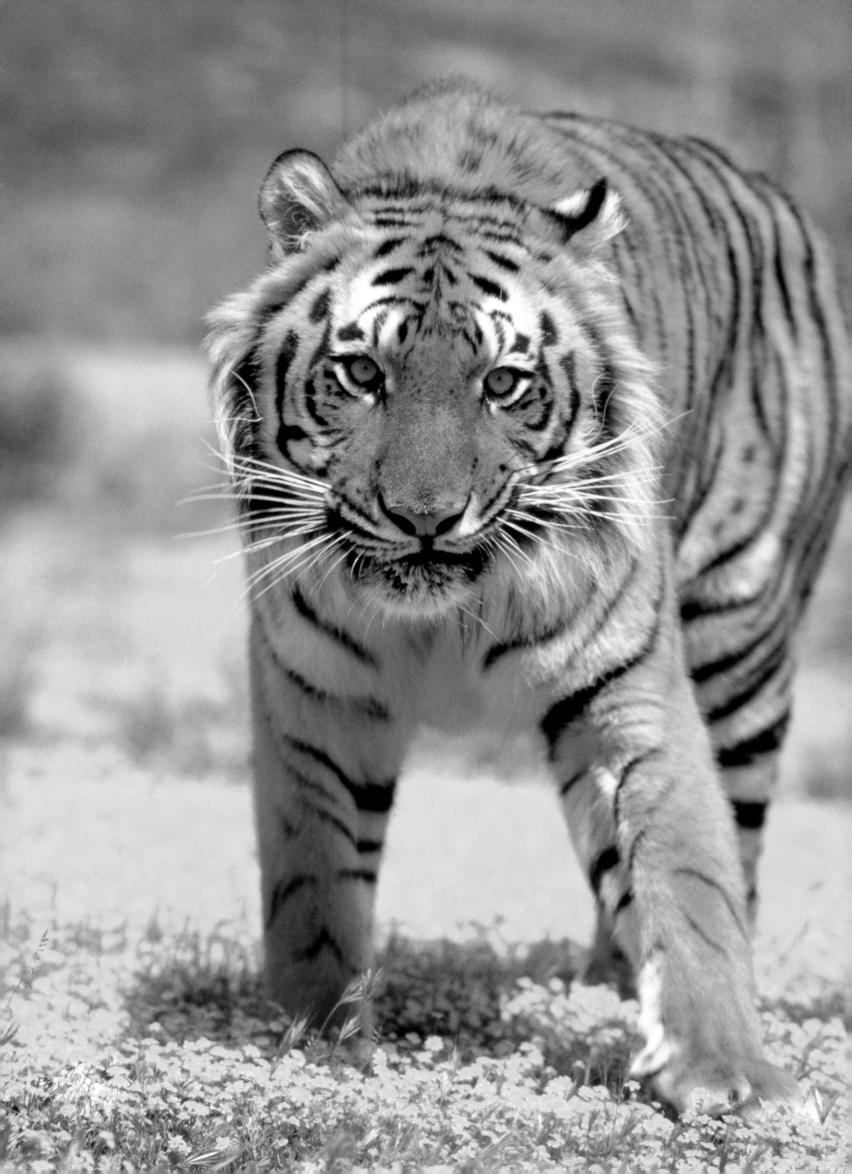

Many big cats kill their prey by biting it firmly around the neck; if this does not kill it directly, the animal will soon die from suffocation, as it will not be released from the grip until it is dead. Whilst gripped in the jaws and held firmly by the sharply clawed front paws, the cat's hind feet—with their more blunt claws—will be brought up with strong kicking movements to tear into the prey animal's belly, often ripping it open in the process.

Once dead the prey will be dragged away to a safe place for a more leisurely meal. Here the great strength of the big cats, such as the leopard, may be exhibited; even quite large antelopes can be carried high up into trees for the purpose.

Cat Senses

Cats have exceptionally good eyesight. Their eyes are set fairly close together at the front of the head, which gives them good forward binocular vision, a prominent feature for all predators, allowing them to judge distances accurately during a hunt. Daylight vision is very good, and most cats also see very well at night. Behind the retina is a special reflecting layer called the tapetum, which reflects light back onto the sensitive cells of the retina. This is what gives cats' eyes the sinister glow when caught at night in a flashlight beam or car headlights.

The prominent external ears of cats are partly directional, giving all cats a good all-

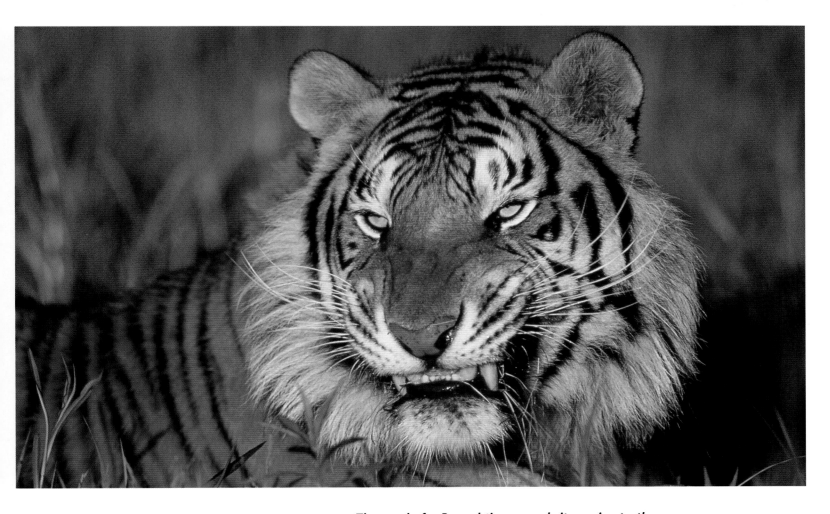

A tiger advances menacingly, the lower lip curling into a snarl as a warning. The ears are turned back and the head is lowered, both signs of aggression which are used to signal to an intruding tiger that this animal means business.

The snarl of a Bengal tiger reveals its canine teeth, the weapons used to bite the neck of prey and suffocate it. A danger signal in all big cats, snarling is a way of showing that it is prepared to attack.

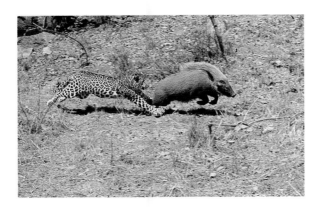

A bush pig fails to make its escape from the clutches of a pursuing leopard. All the pig's agility and speed are not enough to help it evade the leopard's huge, sharp-clawed paws. This predator's lightning reflexes help it make a swift attack.

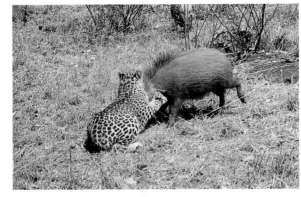

In typical cat fashion, the leopard seizes the bush pig around the neck with its teeth, pinning it down with its strong front paws. The sheer speed of the attack startles the bush pig and leaves it with little chance of escape.

round sense of hearing. They are especially apt at picking up high frequencies and are able to direct their ears forward to accurately pinpoint the source of a sound. They are ever alert to suspicious rustling and squeaking sounds which may give away the presence of prey.

Most cats' sense of taste and sense of smell are very proficient; their ability to detect faint scents of distant prey is vital to successful predation. Dogs probably have the advantage over cats in this regard, as they are far more likely to follow the scent of a prey animal before catching it. However, cats, alerted by a scent, will then use their sharp eyesight to pinpoint prey before stalking it.

A cat's whiskers are important sensory organs, especially at night, enabling the animal to detect objects near its head when moving through vegetation. Whiskers are highly sensitive to touch and are helpful when hunting in confined spaces or in the dark.

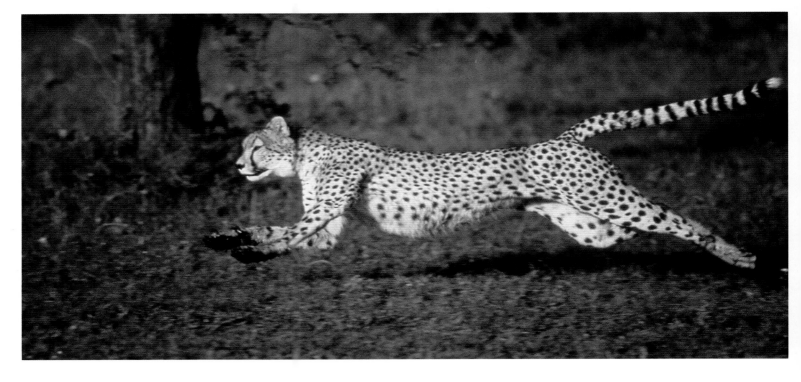

The cheetah is a sleek but muscular cat with a very flexible spine, enabling it to extend and then flex its body fully while running after fast-moving prey like gazelle.

The cheetah's strong jaws clamp tightly around the neck of a Thompson's gazelle, preventing it from escaping and quickly suffocating it. Later the prey will be ripped open by powerful canine teeth.

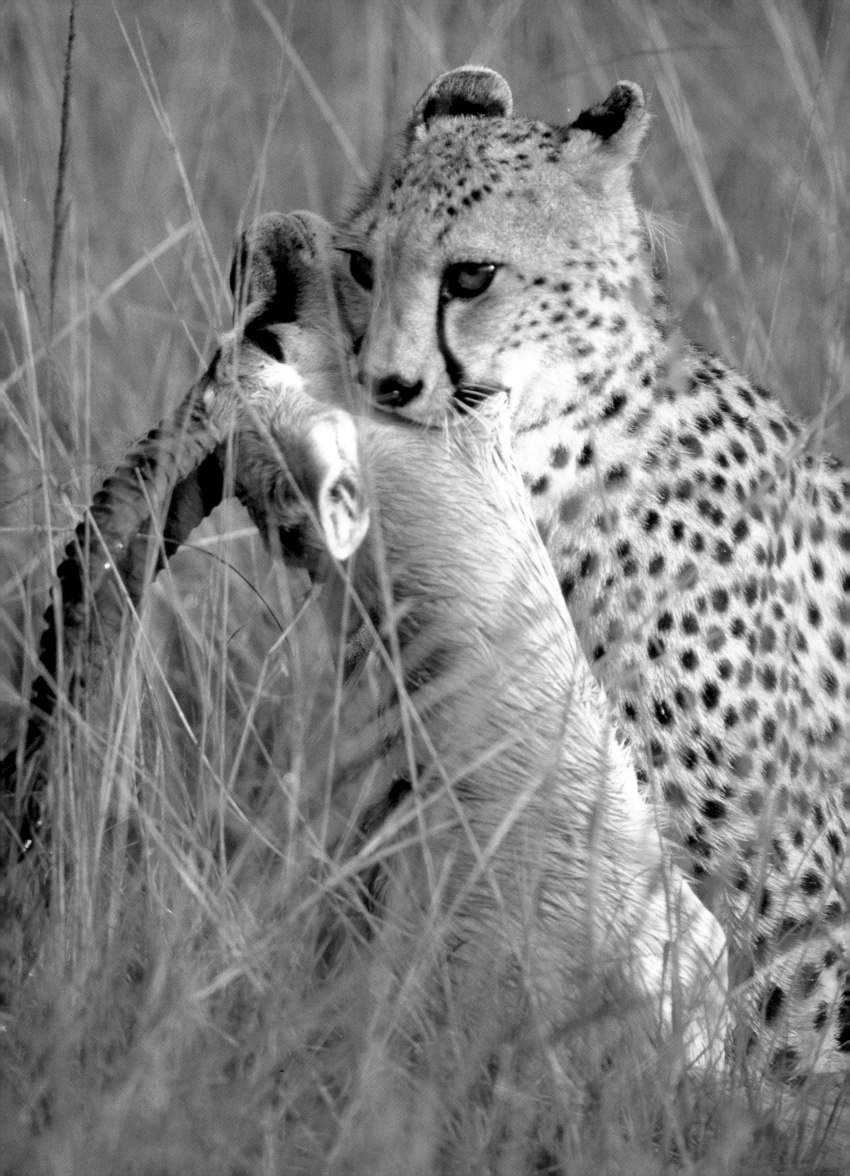

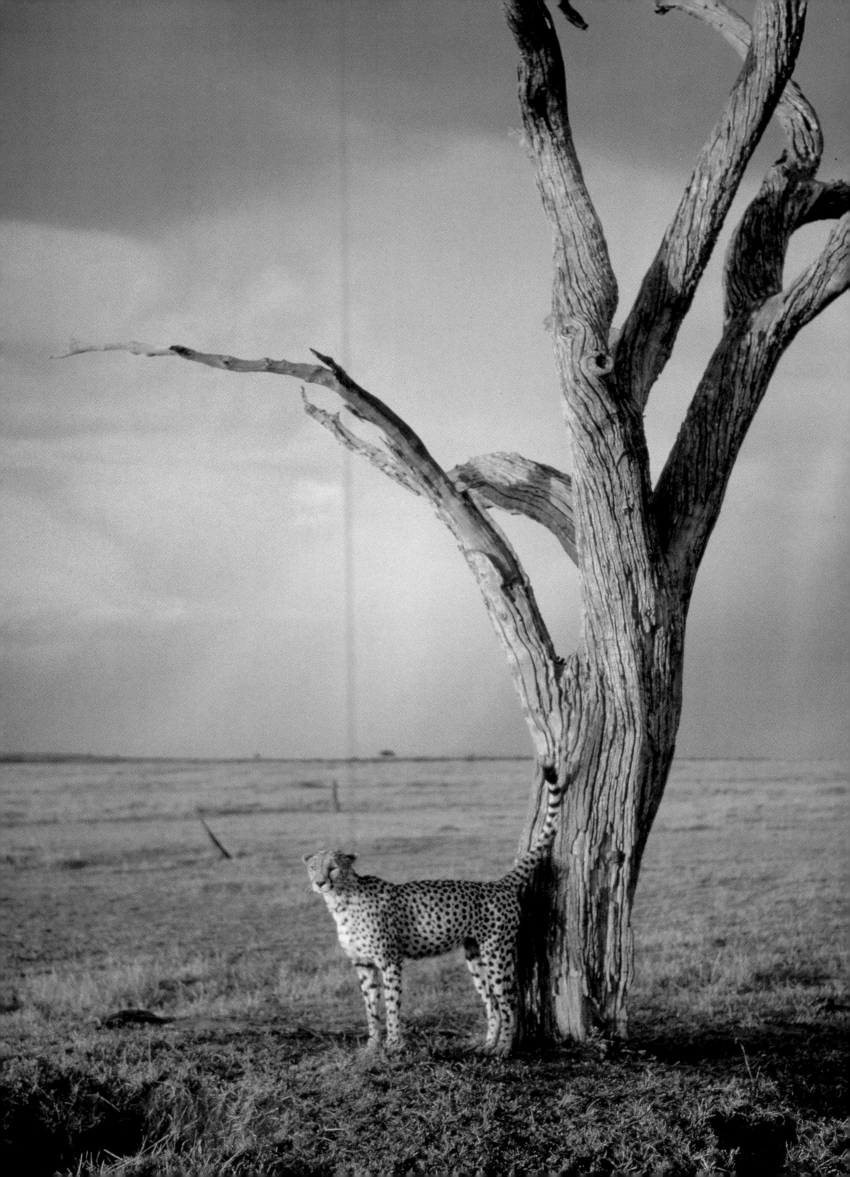

Lionesses drinking quietly at an African water hole are always on the alert. As they arrive to drink most other animals will leave, but the lionesses run the risk of attack from the male lion; even packs of hyenas may attack them if they are taken unawares.

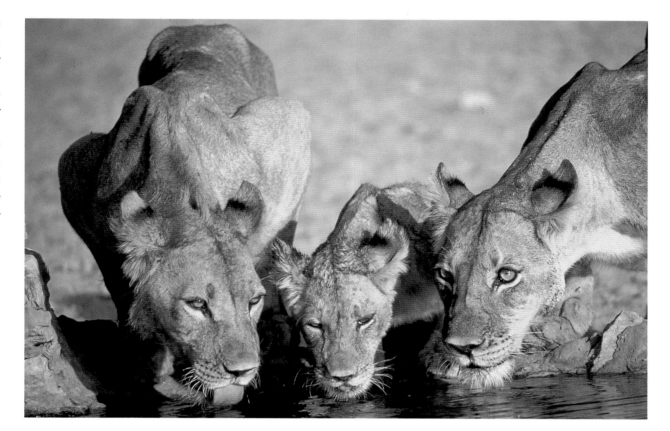

A jaguar pauses beside a Venezuelan stream to check for scent trails. Many of its prey animals will come to the stream to drink, and the same area may be used by a rival jaguar, so caution is needed before he himself takes a drink.

Territorial marking is very important for cheetahs. This adult male is spraying urine on a dead tree in order to leave his distinctive scent as a warning to others.

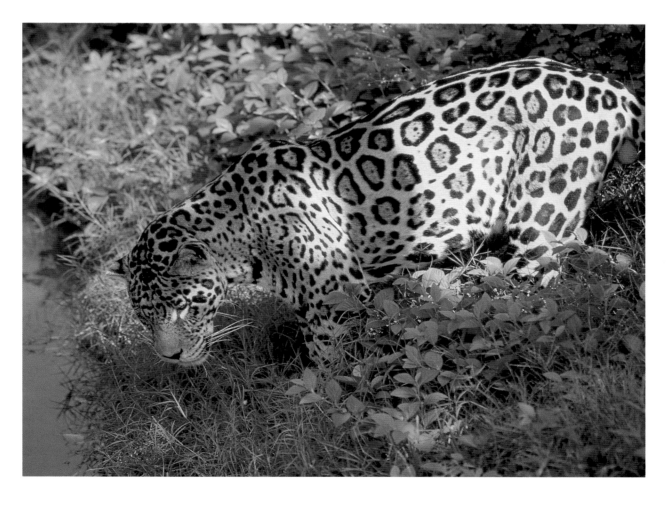

Reflexes

Cats have adept reflexes, which are aided by their array of excellent sense organs; they can react quickly to the movements of prey and also to attacks by potential predators. Cats are very agile, and their lithe, muscular bodies enable them to move with great speed. Many of them are good climbers, possessing an excellent sense of balance; their sharp claws also help them clamber up trees, although coming down again can be a problem.

The ability to stalk silently and unnoticed and then make a sudden dash at prey, pinning it down with sharp claws and powerful teeth, makes the cat family amongst the most efficient of all predators. All cats are exclusively carnivorous, and all hunt their own prey, rarely scavenging or stealing from other animals. Most live in territories which they defend against other cats of the same species.

Family and Territoriality

Cat society is centred around their strongly defended territories, and although many species are solitary for large parts of their lives, they do interact from time to time. Females and their young nearly always stay together for a long period after the young have reached maturity. Even after the young are weaned and able to feed themselves they may stay with their mothers, forming an extended family.

At first they learn hunting techniques by watching their mothers, and then they gradually help with the hunting until they are able to catch their own food. This is especially true of lions, which are probably the most sociable of all the big cats. Males are almost always solitary, however, roaming over large areas in search of food and potential mates.

Amongst the big cats only male lions are regularly found together. In the open spaces of the African grasslands, where food is usually

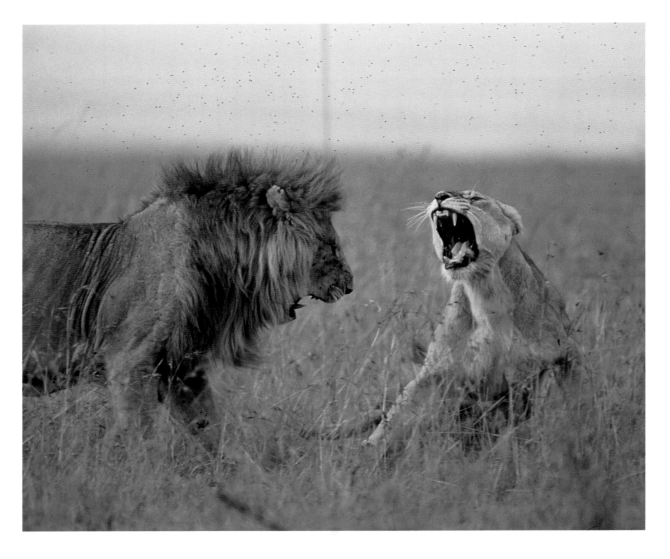

A lioness signals her disapproval to an advancing male intent on mating. He may take the hint and leave her in peace, but sometimes advances cannot be refused and a bloody battle may result.

Courtship and mating is a dangerous business where lions are concerned; the large male will tolerate no intruders and the female will not mate until she is ready. Armed with sharp teeth and claws, each lion knows that another could inflict a serious injury.

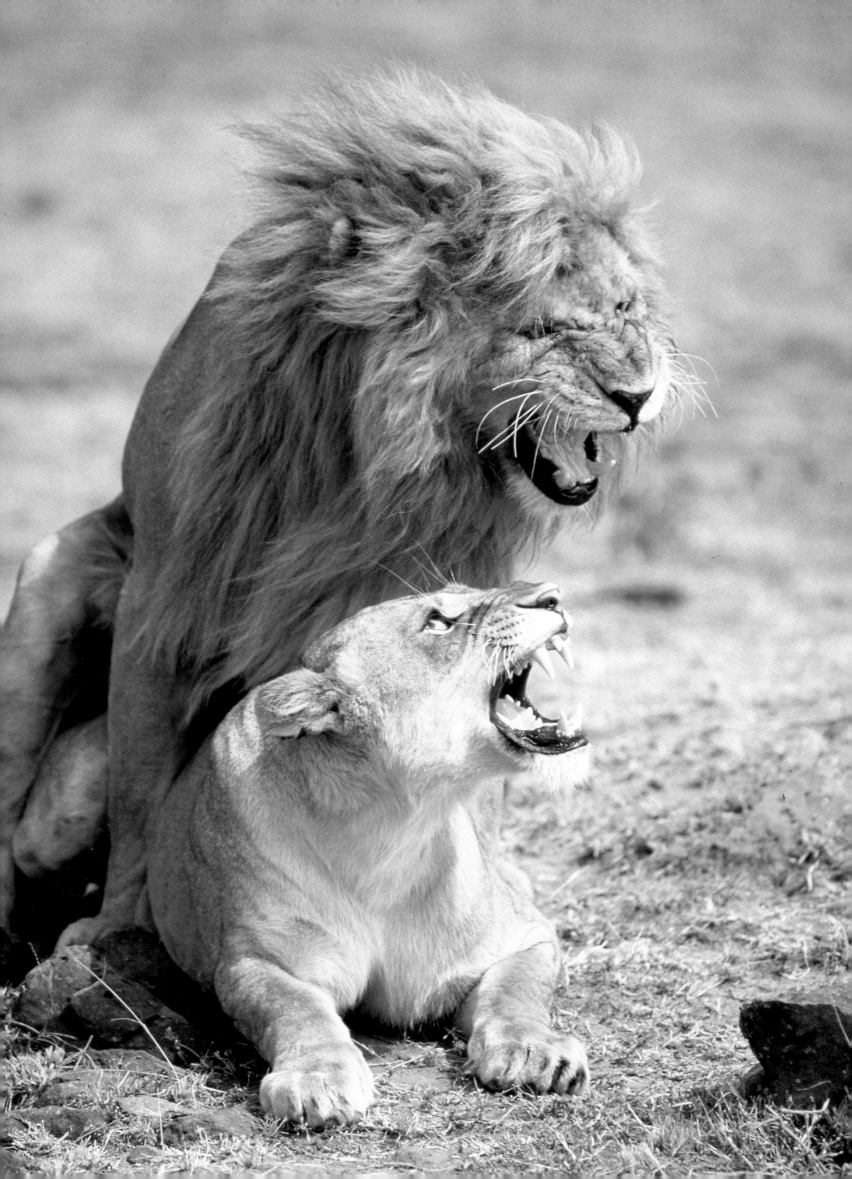

Cheetah cubs play around a fallen tree in the Masai Mara game reserve in Kenya. Play is important in young predators as they practise the skills they will need as adults in order to capture their food.

abundant, these big cats can afford to be sociable. Forest-dwelling cats, and those found in high mountains or far to the north where conditions are severe and food can be scarce, cannot risk competition with another predator and so they try to keep as much land as possible to themselves. The exclusive use of an area ensures that there will be sufficient food for the occupiers of that territory.

Males are usually driven away when cubs are first born, and the females take sole responsibility for their upbringing. In the sociable lions a crèche system operates, wherein several litters of cubs will be cared for by more than one female. For most big cats, however, the cubs will be hidden in a secret location to avoid the risk of being killed by jealous males.

The cubs of all big cats are very playful, and when old enough to leave their dens they spend long hours chasing each other and engaging in mock battles. This is an essential part of the learning process from which they will improve their hunting skills and practise the techniques necessary for coping on their own. Male cubs will probably leave the mother before female cubs. The dominant male in the area will not tolerate other males in his territory, so young males will have to search for an area which they alone can occupy. Many young cubs will die at the stage when they are first forced to fend for themselves.

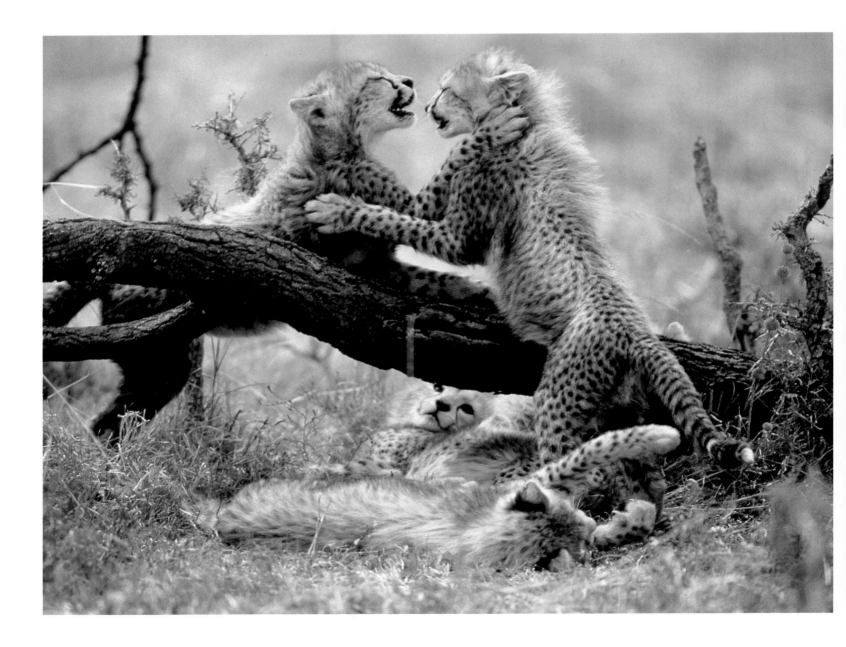

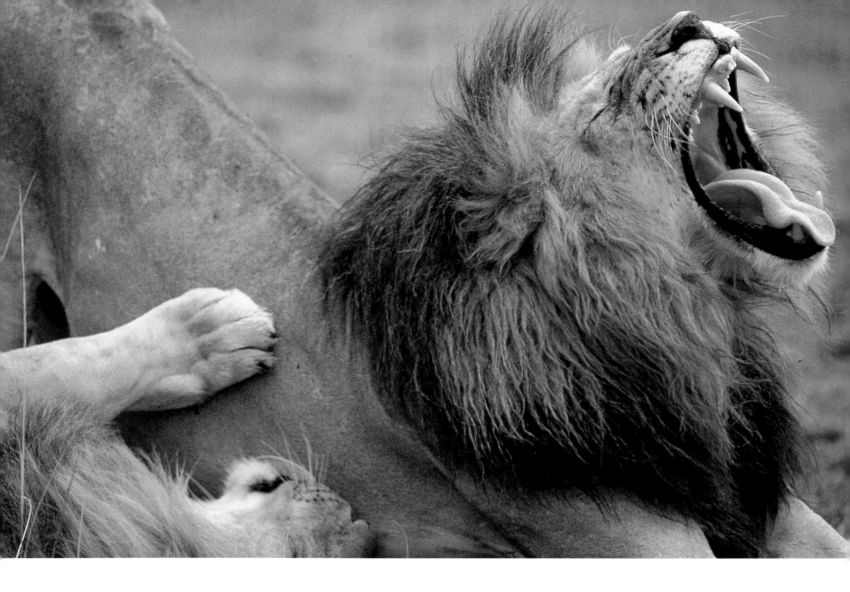

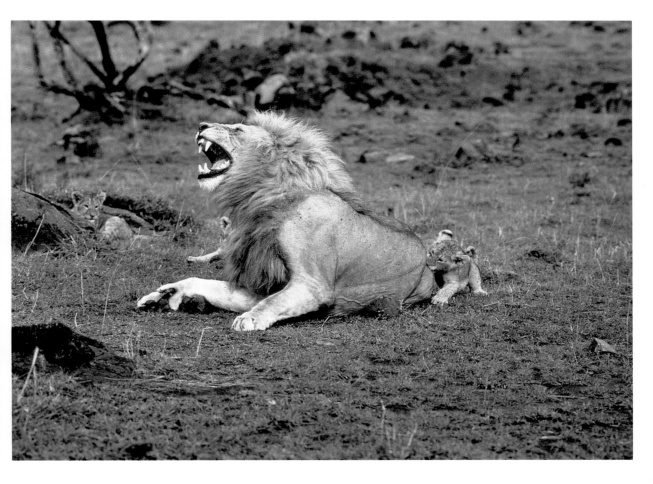

When not hunting or intent on mating, lions may sleep peacefully, and even have time to indulge in mutual grooming. This is a way of strengthening the bonds between individuals and asserting one lion's dominance over another.

A tiny lion cub provokes the king of the jungle with a playful nip. One of the main causes of death and injury in lion cubs is attacks by adult lions, so this youngster may have a painful lesson to learn.

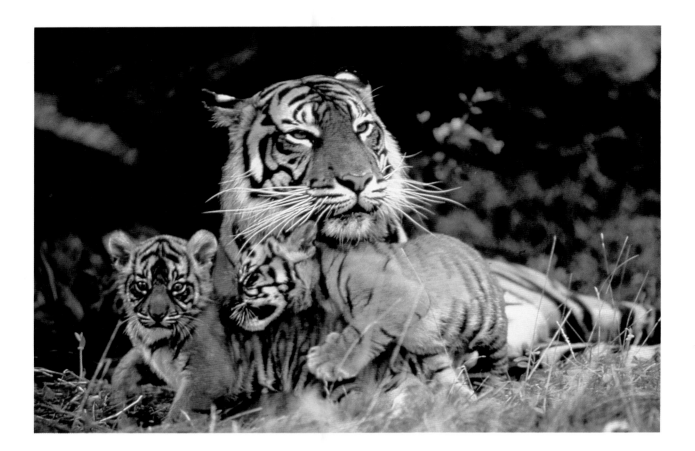

A proud mother guards her two cubs. They will stay close to her until they are able to hunt and defend themselves. Even other tigers are a threat to them until they are fully grown, so their mother's protection is vital.

A playful tiger cub is groomed by its mother. Bonding between a mother and her cubs is strong and the cubs will not stray far from her protection.

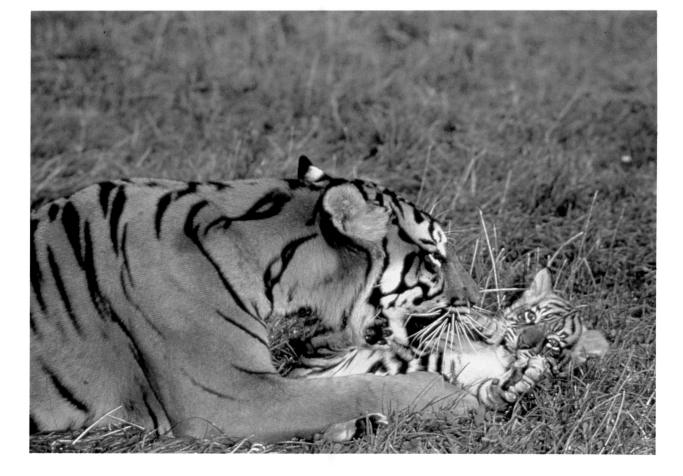

A tigress carefully carries her cub to safety in the usual cat fashion; although it looks painful, the loose skin around the neck is the ideal place for the cub to be held.

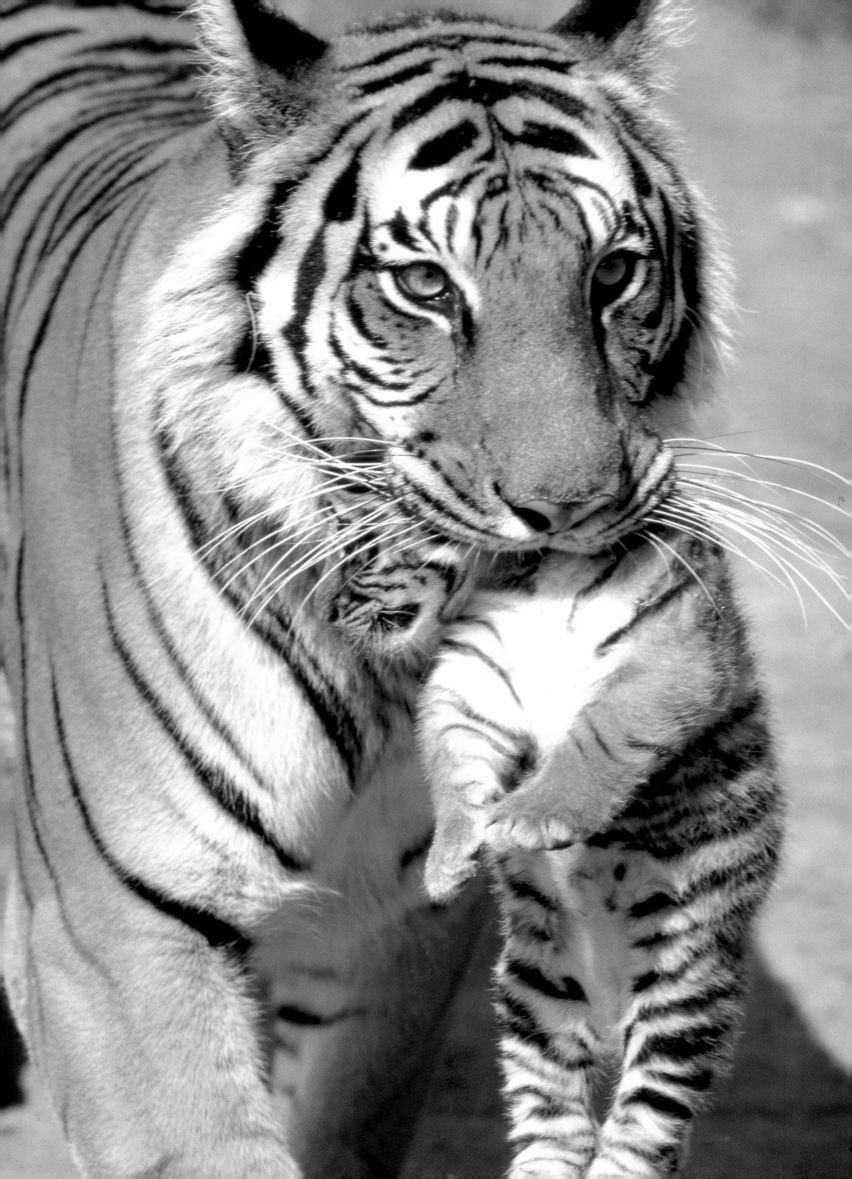

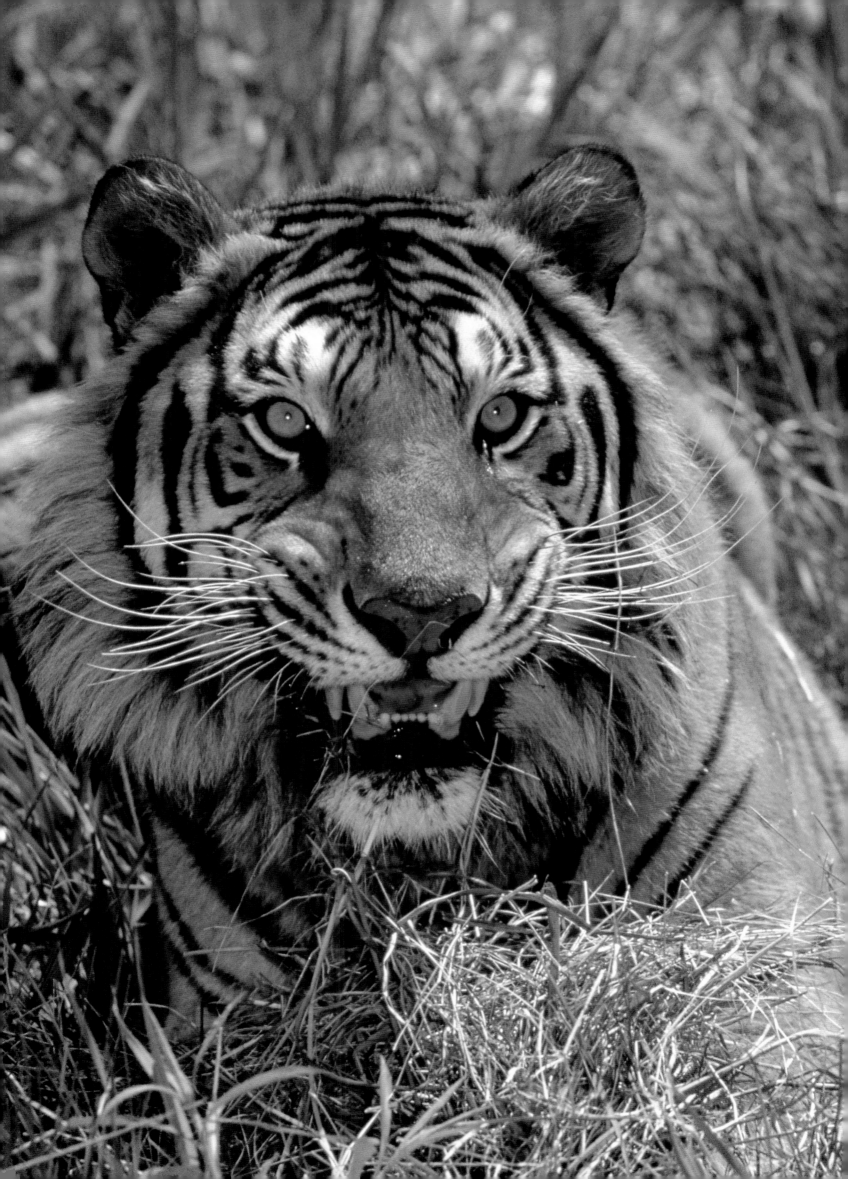

THE KINGS OF THE JUNGLE

Tigers

In the jungles of Asia one animal evokes fear in humans more than any other. The largest of all the cats, and one of the world's fiercest predators, is the tiger. Although its primary prey are large mammals like deer, humans can also be included in its diet, and for this reason it is greatly feared; it is also much persecuted.

The tiger is a solitary predator, living in dense forests, often near water. If tigers are seen together, the group will probably be made up of a mother and her young, who remain with her until they are able to fend for themselves. If feeding is difficult, tigers from different social groups may be seen together at a kill, but normally they adhere to their own territories. The dense forested habitat within which tigers hunt is more suitable for solitary hunting than the cooperative techniques employed by lions.

Females occupy distinct territories which they mark with urine, secretions from the anal glands, and dung. They also make scrapes in the ground and probably use tree-scratching posts as well. These signs are easily detected by other tigers moving through the area. The ranges of different females do not overlap, but the ranges of male tigers are much larger and usually overlap the ranges of two or more females. As they roam over their large territories, the males encounter the distinct markings of the females located within the area, and from these are able to detect their breeding condition by the scents they leave behind.

Male tigers also will be alerted to the presence of any rival males by their scent marks. Although they may not come across the animals themselves, they will be fully aware of the numbers and locations of all surrounding tigers. If the scent-marked sites on the boundaries of the territories are not regularly maintained by fresh deposits, other tigers will assume that the area is not occupied and will quickly move in to claim it for themselves. Thus they are regularly visited and re-sprayed.

Following page: Most cats actively avoid water, but the Bengal tiger readily takes to water and swims well. In the hot climate tigers live in, they can cool themselves off on sultry afternoons and are able to pursue prey more easily as swimmers.

A snarling Bengal tiger shows off the impressive canine teeth with which it bites into the neck of its prey. The smaller incisor teeth at the front are used to help rip flesh from the bones of the prey once it has been killed.

Excellent eyesight, hearing, and sense of smell give this Bengal tiger the ability to detect its prey in the dense forest it inhabits. Even at night it will have no difficulty in locating its victim and stalking it through thick vegetation.

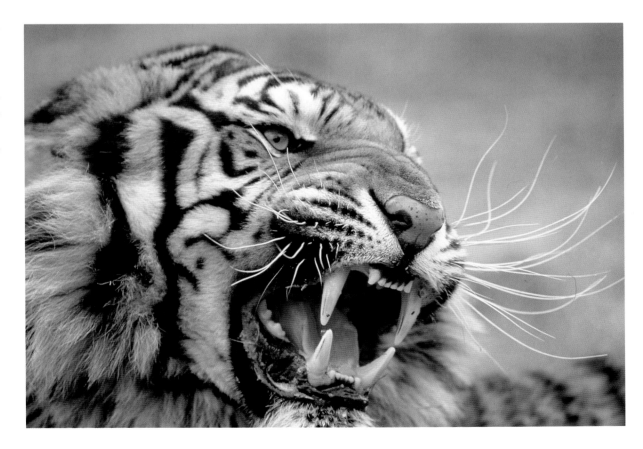

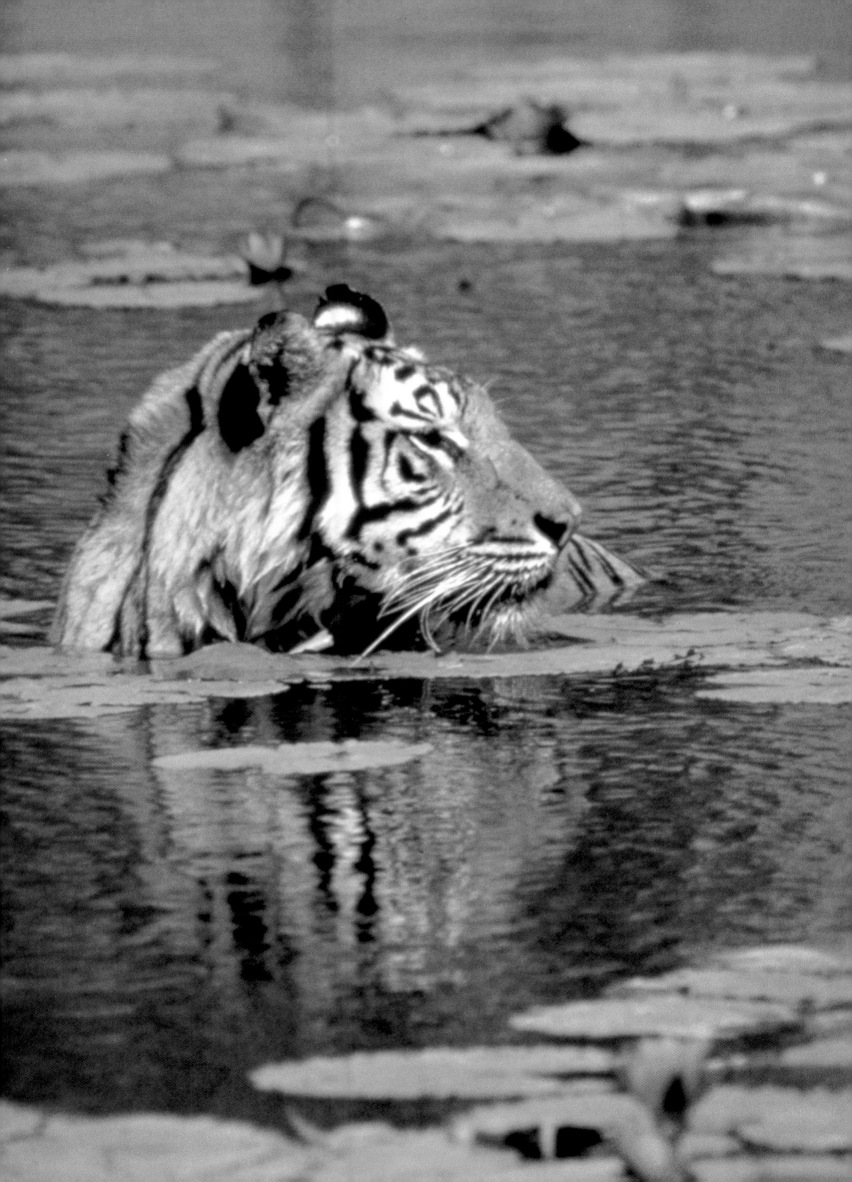

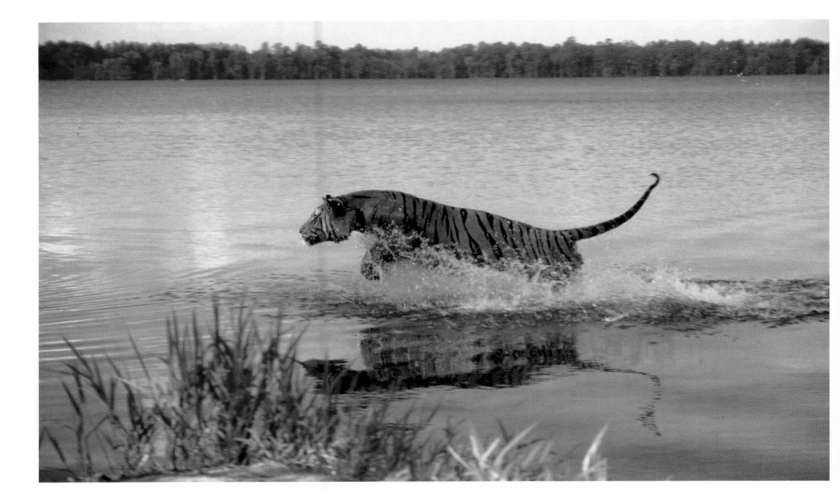

A river or lake is no obstacle to tigers, who show no fear of either deep or running water. Any prey animal such as a deer which tries to flee through water will find that the tiger can easily follow and probably out-man-oeuvre it as well.

Maintaining a territory is very important to the survival of the tiger as it results in its becoming very familiar with an area, knowing the best places to find prey, safe areas for breeding, and danger spots where other tigers may be encountered. Females rearing young will need to have easy access to food and will not be able to waste time searching in unfamiliar places. In addition, as the young grow larger they will need a safe area in which to practise their hunting techniques.

The tiger is a very strong cat with a heavy muscular body adapted for coping with large prey. Its hind legs are longer than its front legs; this makes it easier for it to jump onto its prey. The shoulders and front legs are strongly muscled, enabling the tiger to grasp its prey whilst the huge paws and sharp claws hold it in a tight grip. Like all cats, the tiger has short jaws, which effectively increases the leverage on its carnassial teeth and gives it an immensely powerful bite. Its prey is normally killed by a single strong bite with the long, slightly flattened canine teeth.

The tiger's normal hunting strategy is to stalk its prey through dense vegetation and then ambush it, pouncing at the last moment, when the prey has no chance of escape. Any animal, even one as large as a deer or a human, is quickly overcome by this surprise attack and is unlikely to get away. The sheer weight of the tiger is often enough to knock the prey down, and even animals as formidable as elk and bison are easily tackled. The usual method of attack is to jump from the side or the rear of the prey, grasping it firmly around the neck with the front paws and the teeth. A small deer may be consumed in one meal, but a larger animal such as bison may sustain the tiger for several days.

A female with young will make short work of large prey. She will remain near the carcase, guarding it against rivals and scavengers, until only bones remain. A female with two cubs will probably need to kill a large animal every five to six days, but a solitary male or female may kill only once a week, particularly if the prey animals are large.

The tiger's striped coat provides it with effective camouflage in forests and scrub, and its soft, well-padded feet allow it to move silently. Good senses keep the tiger informed of the movements of its prey, so most of its attacks are successful. Tigers drink whilst consuming their kill, and will often drag their prey near a source of water.

Of all the cats, the tiger is most at home in or near water. Apart from drinking with their meals, tigers will spend long hours during the hot season cooling off in streams, either standing or lying in the water. They swim well, and will not hesitate to pursue prey into lakes or rivers.

Attacks on humans are well-recorded and usually occur when the tiger becomes old or injured, and is unable to catch active prey such as deer. This may lead them to stray near human settlements. Sometimes humans encroach onto tiger territory; clearing forests for agriculture will result in less habitat available for tigers to hunt in, increasing its chances of contact with humans. Sometimes a chance encounter by a young tiger with a human will lead to the person being killed, and thus the animal acquires the reputation of man-eater.

Normally tigers shun human contact, and if a

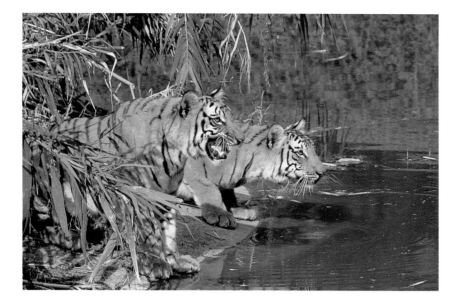

young tiger has an unpleasant encounter—being shot at or driven away by fire, for example—it will probably lessen its chances of becoming a man-eater. If tiger reserves are large enough and stocks of prey animals like deer are maintained, there is less likelihood of them ending up as a threat to humans.

A pair of Bengal tigers at the edge of a stream consider the possibility of a dip after taking a drink. Tigers are more at home in or near water than any other big cat, using rivers both for cooling off and for pursuing prey.

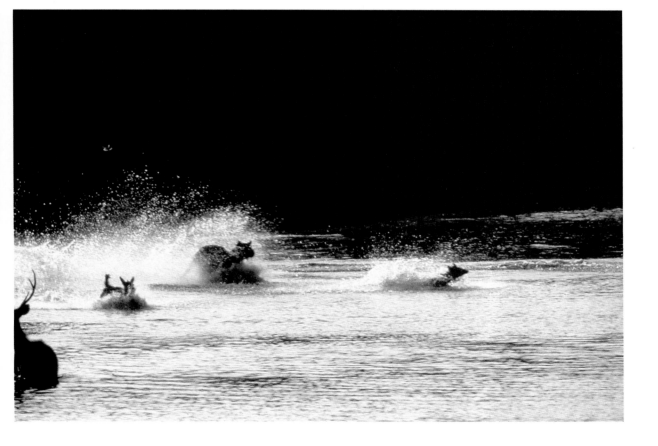

In the final moments of a chase, a tiger runs down the calf of a sambar deer, scattering other deer in panic as it splashes through a shallow river.

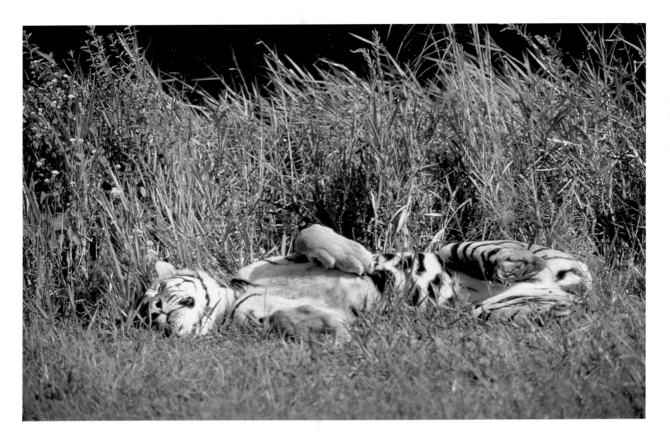

In the heat of the afternoon sun, even the tiger will relax and sleep, luxuriating in the warmth of a bed of dry grass. The tiger has nothing to fear except other tigers and man.

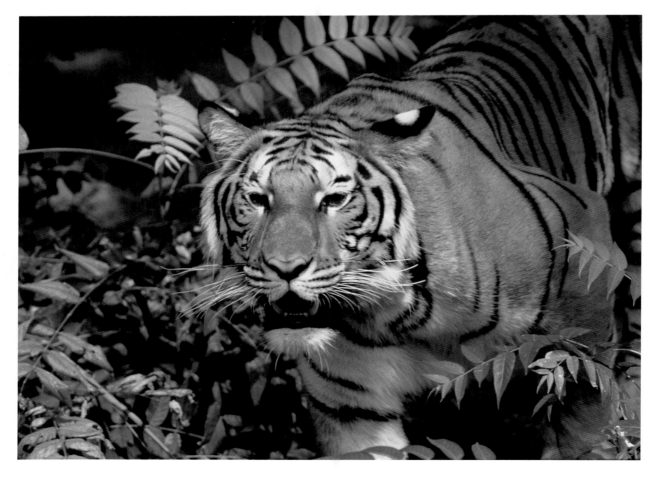

Despite its great size, the Bengal tiger is able to move through the forest in silence, stalking sensitive prey like deer without alerting them to its presence.

A rare genetic mutation occasionally gives rise to a white tiger, in this case the race known as the Bengal tiger. This is not a true albino, however, as the dark stripes are still very prominent and the eyes are a normal colour. The white tiger may find it more difficult to conceal itself in the forest.

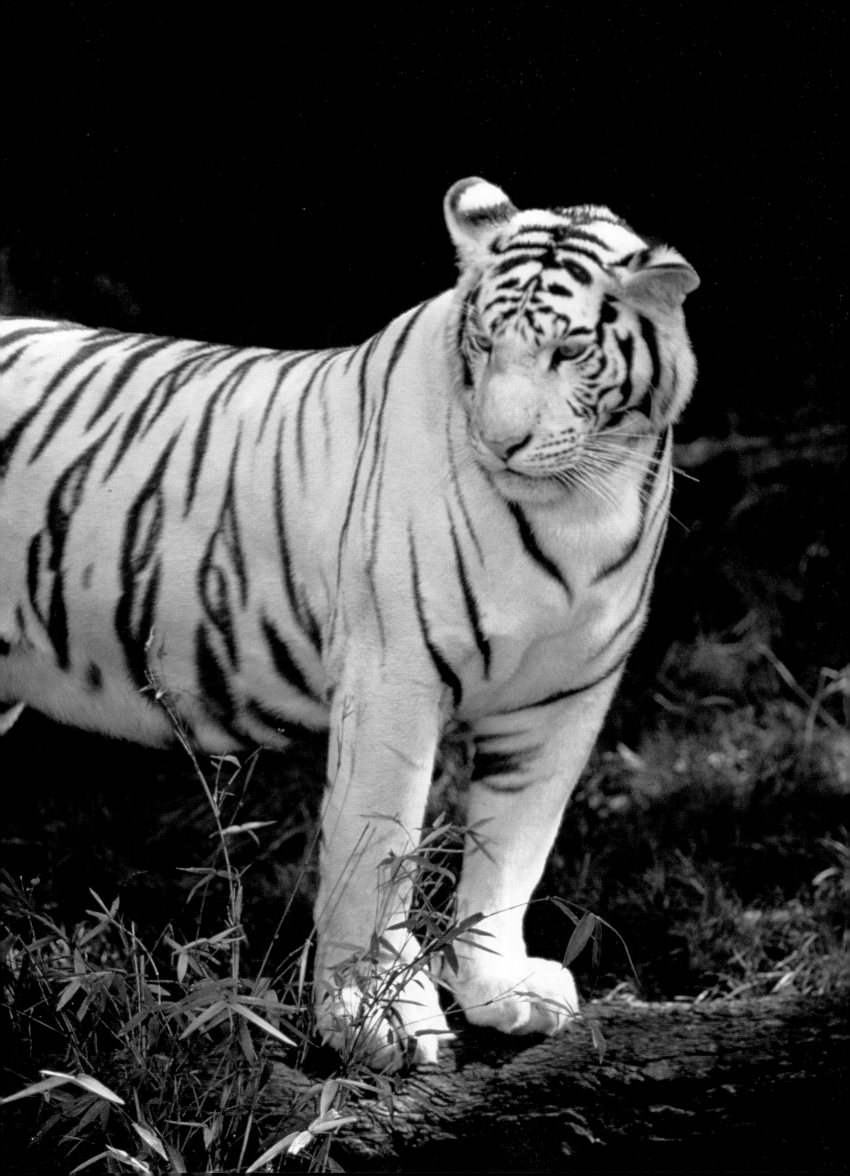

Leopards

The forested areas of central and southern Africa, the tropical forests of Asia, and mountains up to the snow line are all home to the leopard. Its spotted coat provides it with superb camouflage in trees, at night when stalking quietly through scrub, and when lying motionless in the dappled shade of a forest.

The leopard is a highly skilled hunter, at home in trees and on the ground, and is now the most widespread of all the big cats. Its typical form is a spotted coat, with small dark spots on the head contrasted with a brownish fawn background. Larger spots adorn the underside and the legs, and the flanks are marked by spots arranged in rosettes.

The leopard is more stocky than the cheetah, but slimmer than the jaguar, and may sometimes have an almost black coat. Confusion surrounds the leopard's different colour forms; the black leopard is sometimes mistaken for the 'panther'. In the Malay

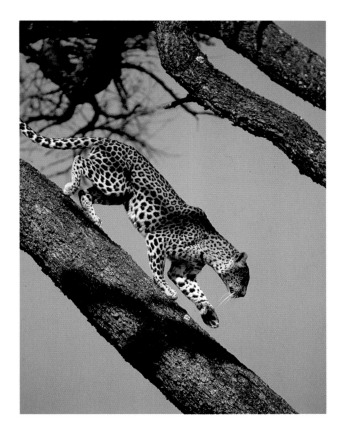

Climbing up a tree is usually no problem for a leopard, but getting down may be more difficult. Some run at it, using their agility and good reflexes to judge the easiest way down. The backward-pointing claws are no help when descending.

An impala will make a good meal for a leopard and its family but it will also attract scavengers, so it must be carried to safety as quickly as possible. The leopard's skill at tree-climbing helps it here as the prey will be safe stored off the ground.

Of all the big cats, the leopard is most at home in trees and regularly sleeps high off the ground. The cubs learn to climb at an early age and are left in trees for their own safety whilst their mother goes off to hunt.

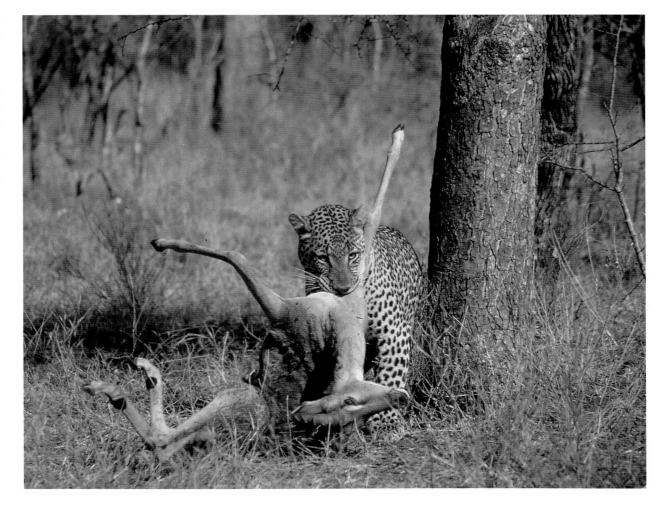

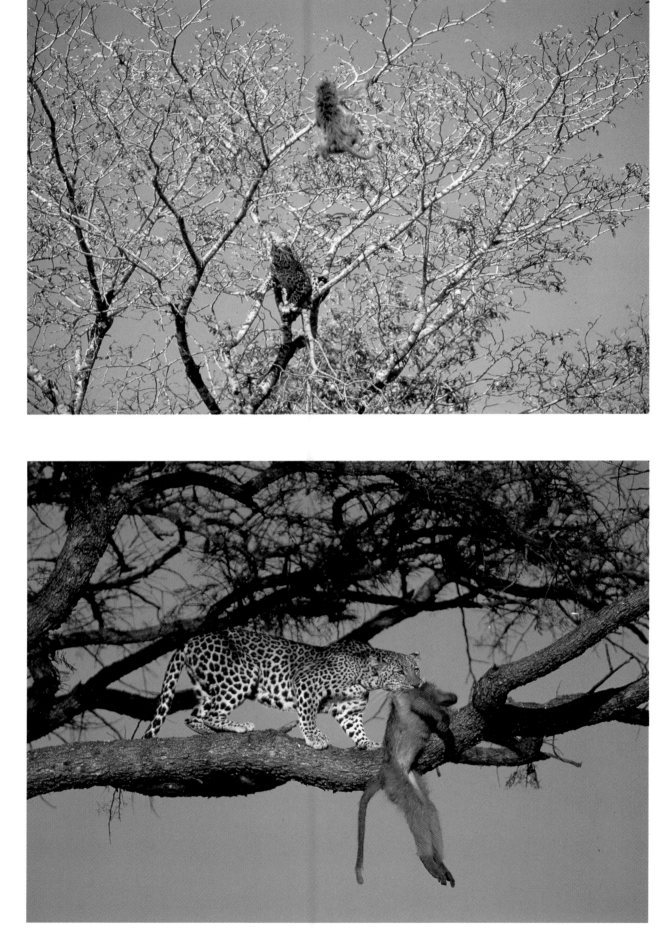

A leopard chases a baboon, using its tree-climbing skills to make a swift attack. Even agile monkeys must take care when a leopard is hunting, for with its speed and sharp claws, the leopard makes a ruthless predator.

Once captured, the baboon will be treated like other prey and stored in a safe position high above the ground where only a leopard can reach it.

A powerful cat like the leopard can easily carry an impala up into a tree; here, away from scavenging hyenas, it can supply food for several days.

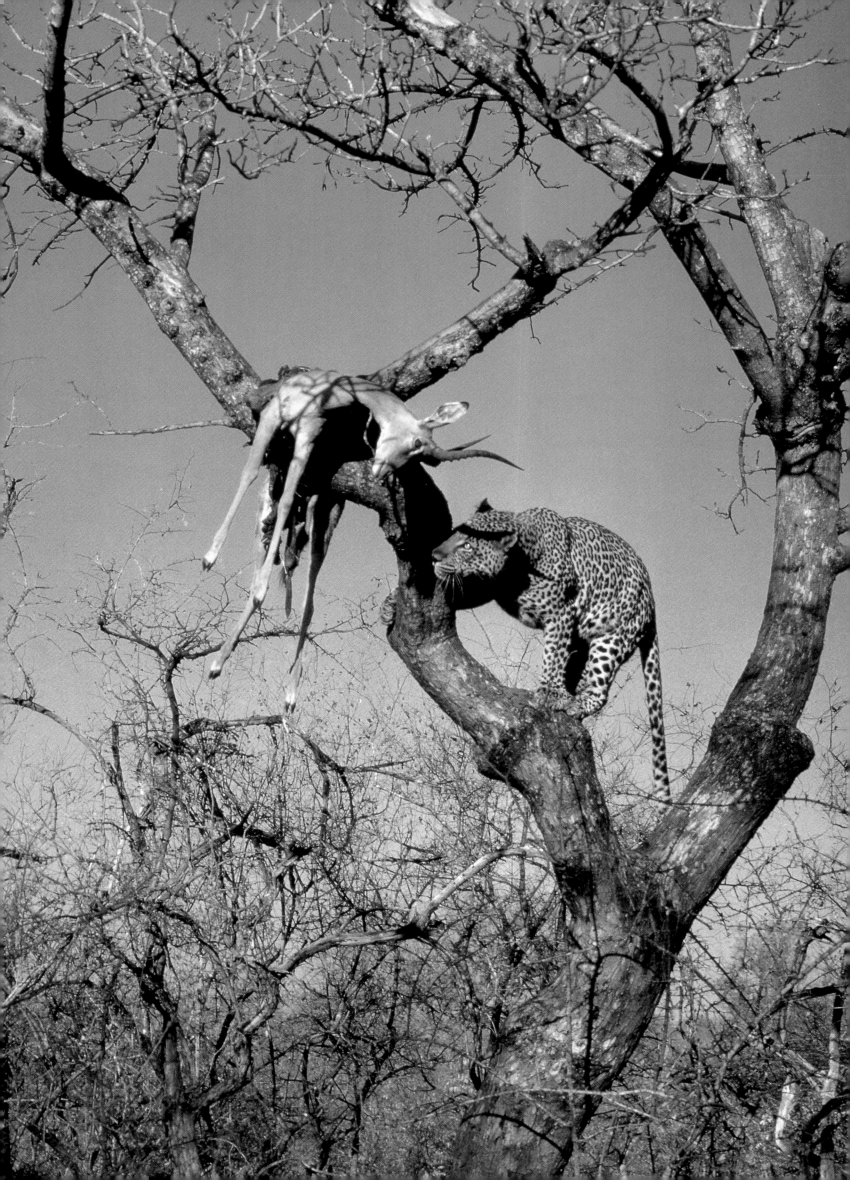

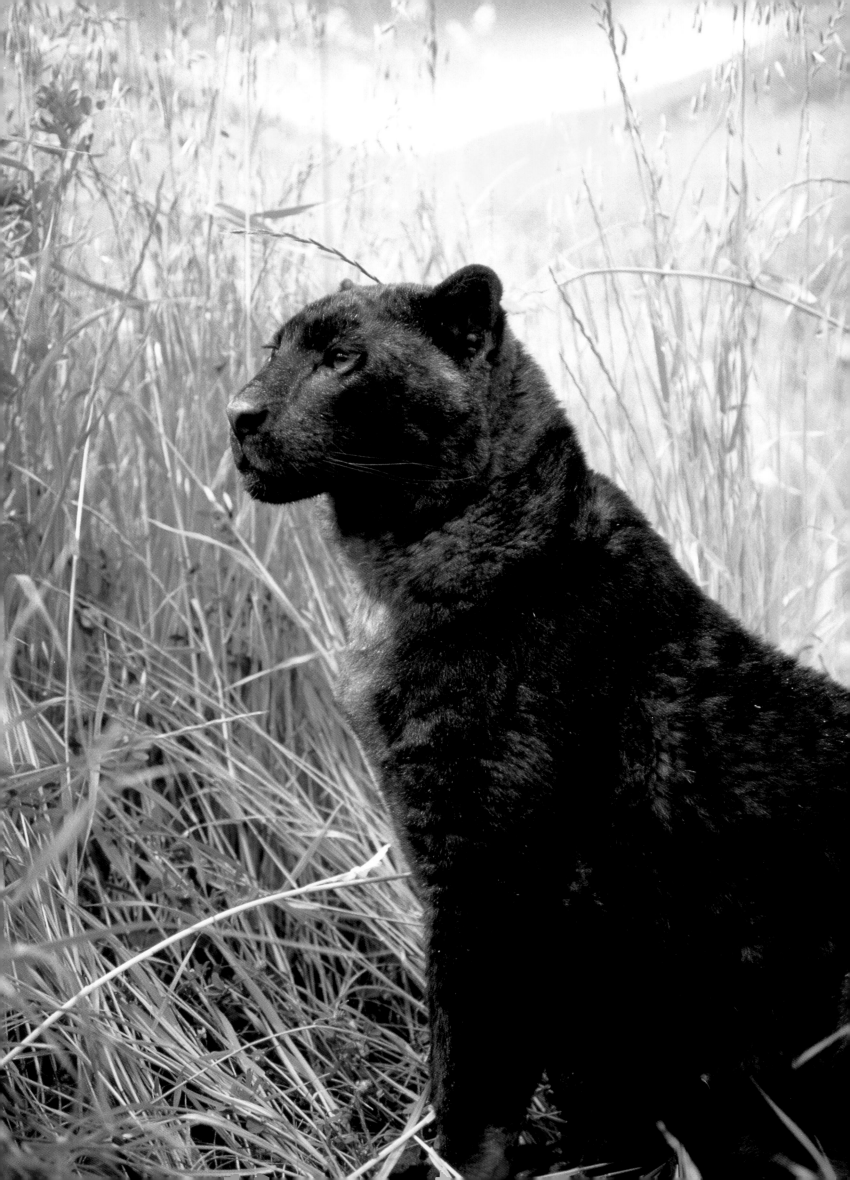

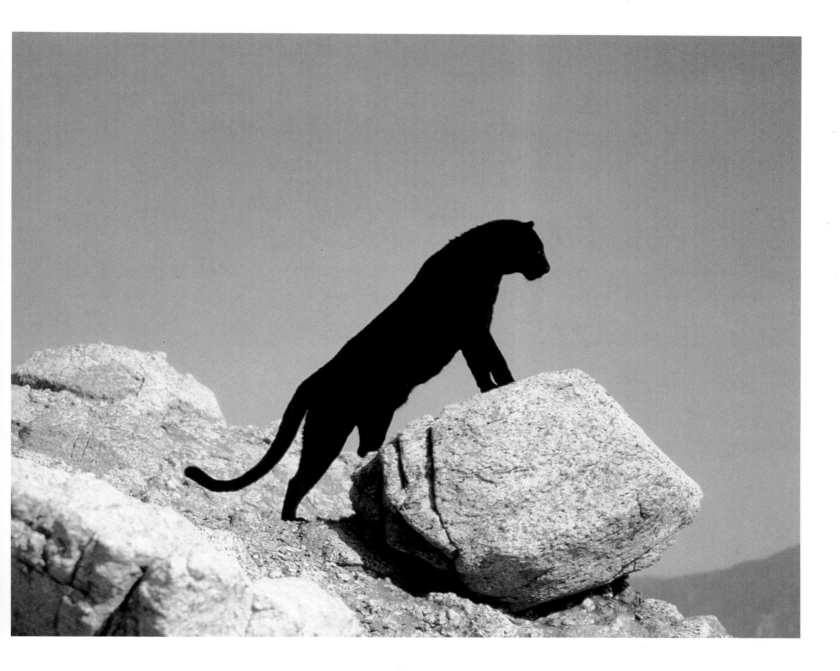

peninsula almost half the leopards may be black, and in other parts of its range the black form is more common in forested areas.

Leopards catch their prey by a combination of hunting methods. They are great opportunists, so they may lie in wait for an approaching animal, leaping onto it at the last moment, or they may make short dashes after it, rather in the fashion of a cheetah.

The normally spotted coat of the leopard is sometimes very dark; this melanistic leopard shows only a few traces of the dark spots.

They are normally solitary, and nearly always hunt at night, sometimes concentrating on small prey.

One feature which distinguishes them from most other large cats is their habit of dragging their prey up a tree after killing it, thus keeping it from competing predators like lions and such scavengers as the hyena.

Female leopards have no set breeding season, producing litters of about three young whenever feeding is good. The males play no part in rearing the young, who stay with their mother for up to twenty months. The young will be ready to breed when they are around thirty months old.

A startlingly black leopard stands silhouetted against the sky; leopards often use vantage points like rock outcrops to survey their surroundings. In the absence of trees, which leopards are easily able to climb, a high rock will make a good lookout.

Jaguars

The tropical forests of South America are home to the jaguar, a larger and more heavily built cat than the leopard, which it somewhat resembles. It is the only large cat species in the Americas. It shares characteristics with the leopard and tiger of the Old World, such as tree-climbing and swimming, although it normally hunts on the ground. It has huge paws and a large, broad head with powerful jaws.

In Amazonia there is a belief that jaguars catch fish by twitching their tails over the water, which attracts them to the surface. They have been seen to swipe fish from the water with their large paws, although the tail-twitching may not have had anything to do with the capture. More common prey for the jaguar are mammals such as peccaries, tapirs, and monkeys, although many birds, fish, and reptiles are known to be taken. Jaguars often bury their prey before returning to eat it.

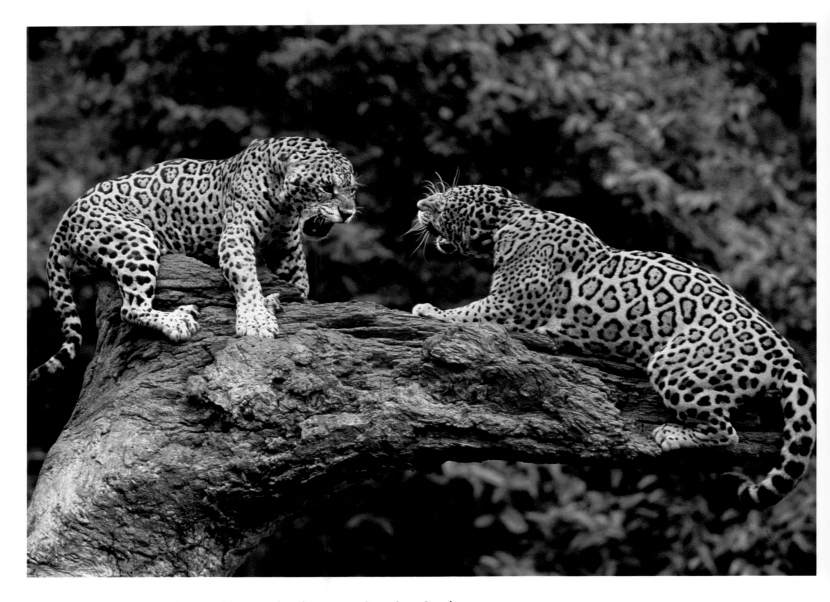

A pair of jaguars battle over territory in a South American forest. These fierce conflicts usually end with one animal retreating before any real harm is done; the victor will then patrol his territory to be assured that the rival has left the area.

The beautiful coat of the jaguar has led to its persecution by fur trappers. Thus this great hunter of the forests of South America is now very scarce and rarely seen. It does not frequently leave the forests, but may occasionally be glimpsed in a clearing.

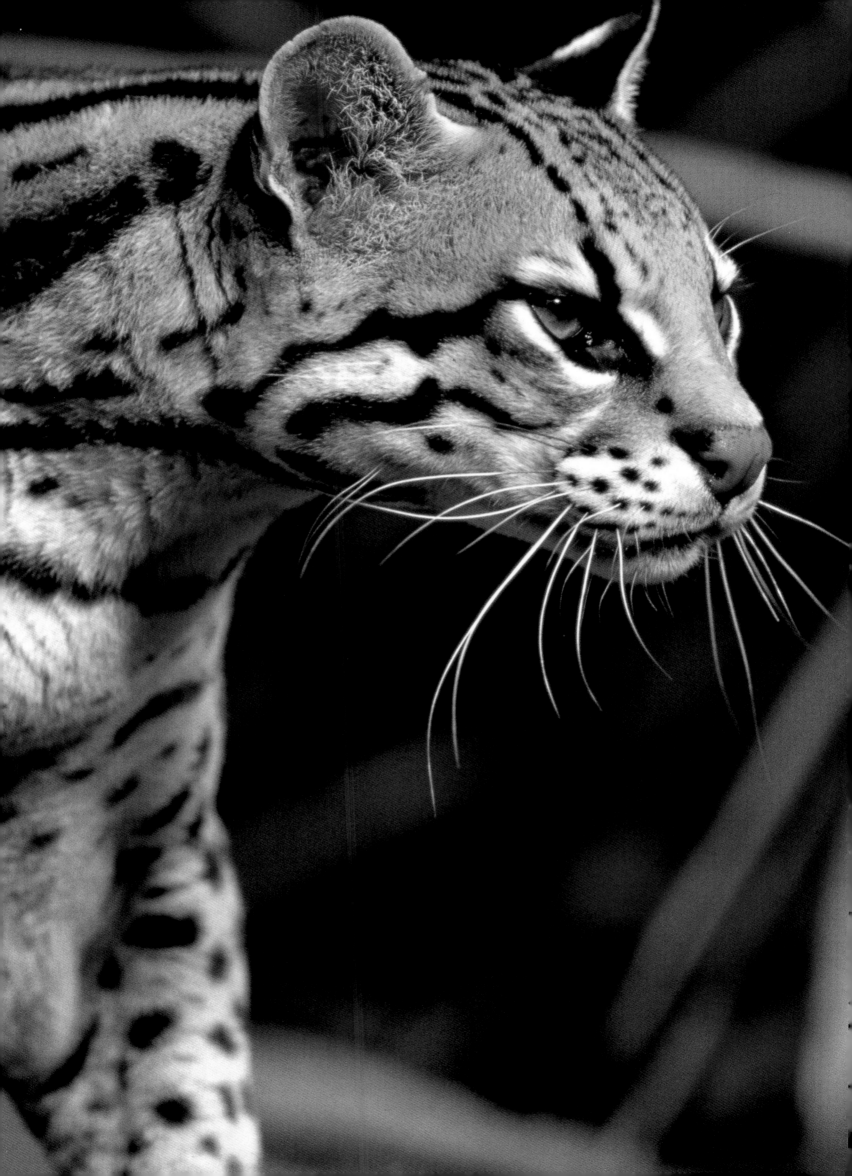

Ocelots

A much smaller cat found in the South American forests is the ocelot, best known for its beautifully marked coat. Bold stripes and spots on a rich ochre background make it a most attractive animal. The ocelots found in forests have the most striking coats; those which live in more open areas have plainer coats to match their surroundings.

Ocelots are extremely good climbers and can also swim well. Unlike most cats, they often live in pairs. This species has been hunted ruthlessly by fur trappers who have sold its boldly marked pelts for use in manufacturing fur coats. Large numbers of these small cats are needed to make a single coat, hence tens of thousands are killed every year.

Margay Tigers

The Margay tiger is similar in appearance to the ocelot, living in mixed forests from

Mexico south to Argentina. It too is an excellent climber, quite capable of catching arboreal prey such as monkeys and squirrels. It suffers as well from the attacks of fur trappers and its numbers are sadly depleted.

A Cape wild cat uses its speed and agility to escape from the gaping jaws of a crocodile. Easily able to out-manoeuvre a large reptile like this, the alert wild cat will continue to hunt for its own prey along the waterside.

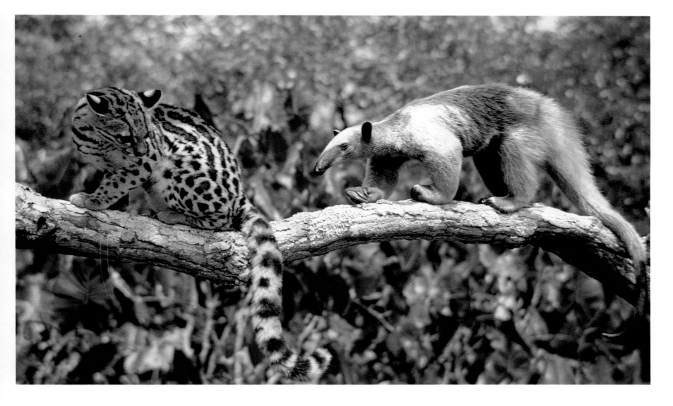

The ocelot has a beautifully marked coat of very fine quality, and like other big cats it has suffered for it at the hands of trappers in order to provide fur coats for humans. It is now an endangered species and very difficult to find in the wild.

A Margay tiger in a South American forest meets a tamandua, or tree-climbing anteater. Tamanduas are slow moving but defend themselves with an unpleasant odour, so the cat will probably not attack.

Following page: In the forests of Central and South America the jaguar is the largest and fiercest hunter, sharing characteristics with the leopard and tiger such as tree-climbing and swimming.

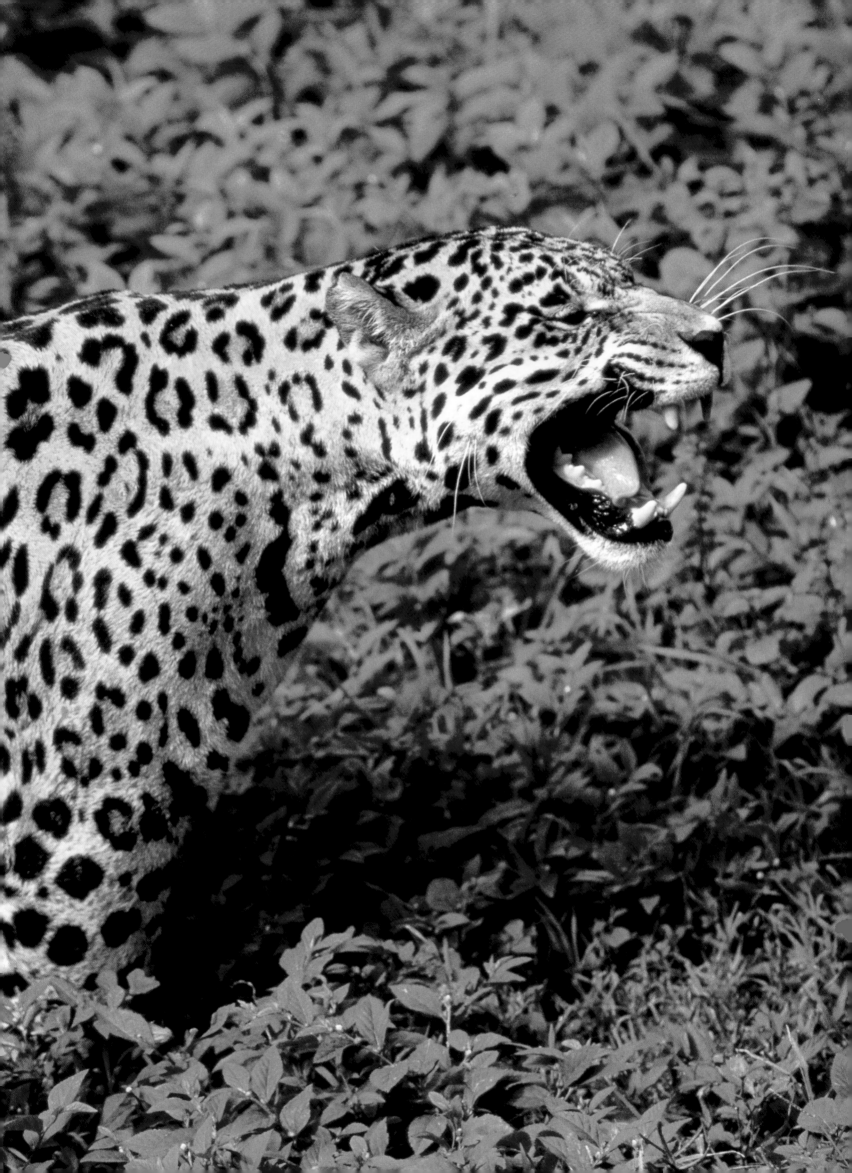

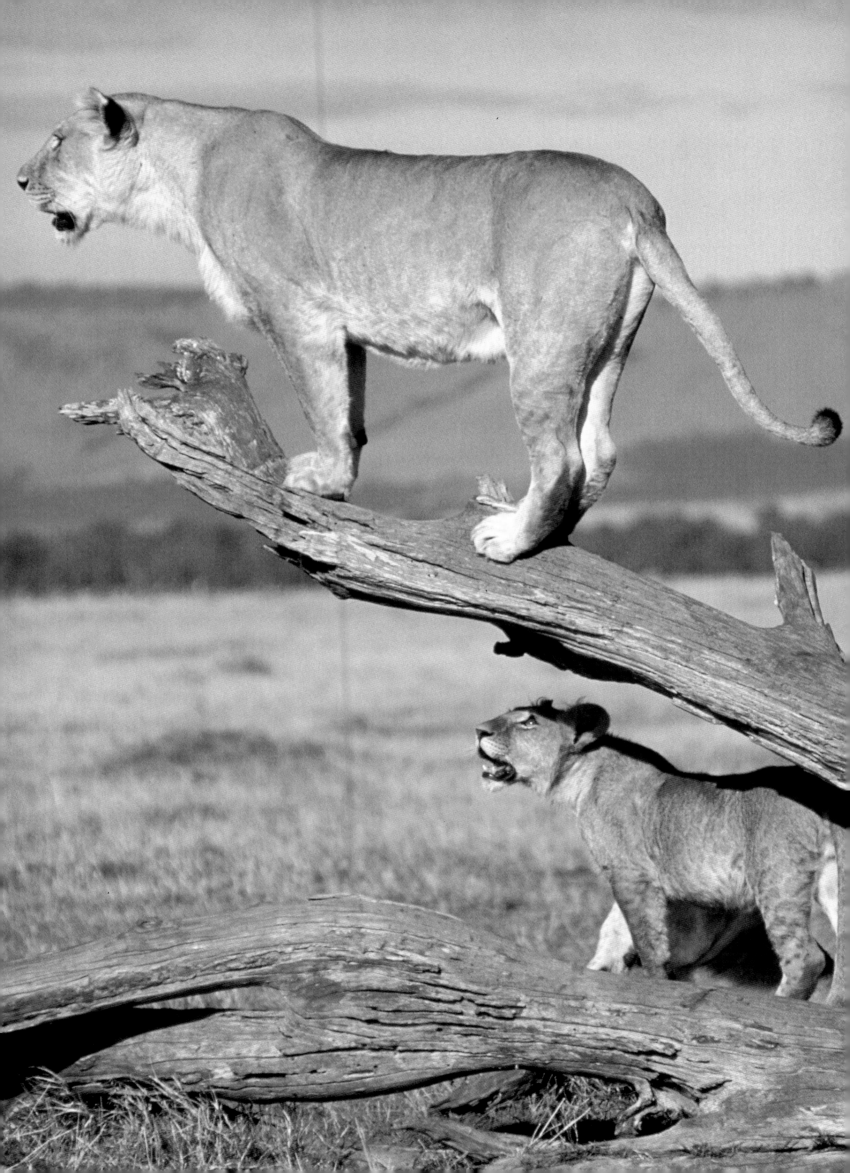

THE PLAINS DWELLERS

Lions

The so-called King of the Jungle is actually an animal of the open plains rather than the jungle. The lion is legendary amongst hunting animals for its strength and ferocious predatory habits—it more correctly could be called the 'King of Beasts'.

Lions were once widespread across Africa, southern Europe, the Middle East, and India. Now they are largely confined to the plains of East Africa, with a few scattered colonies elsewhere, including Gir Forest in northern India.

The lion is a formidable predator with a strong, muscular body; lithe and agile, it runs extremely well. It also possesses strong

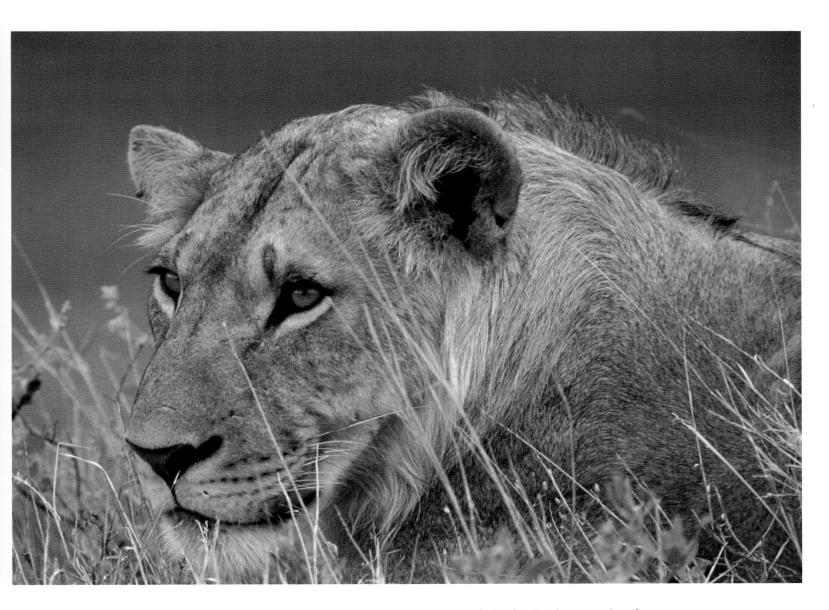

The dominant female in a pride of lions surveys the Masai Mara reserve in Kenya. The young lions below her, showing their more spotted coats, will learn hunting techniques from experienced adults.

A lioness resting quietly in the Samburu National Park in Kenya looks peaceful enough, but her good hearing and eyesight will alert her to the approach of other lions or the presence of prey.

The large and aggressive buffalo is a match for a lioness, especially if close to the rest of the herd. However, if this animal becomes separated or injured, the lioness and the rest of her pride will make short work of it.

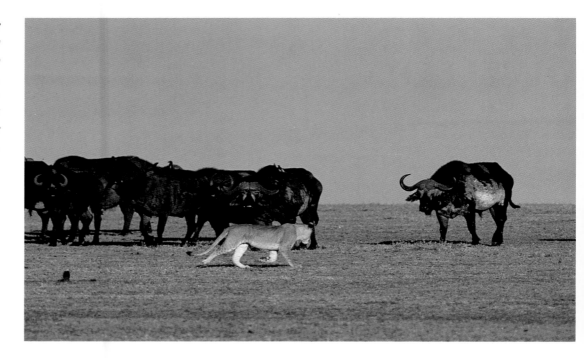

In the heat of the Kalahari Desert a lion needs to make regular visits to the waterhole. He can be certain that he will be able to drink his fill, as no other creature would risk challenging him.

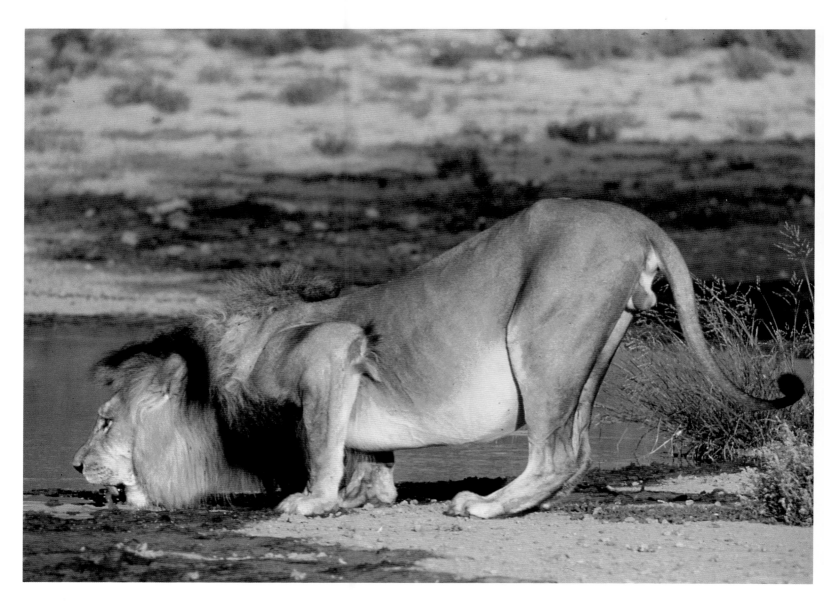

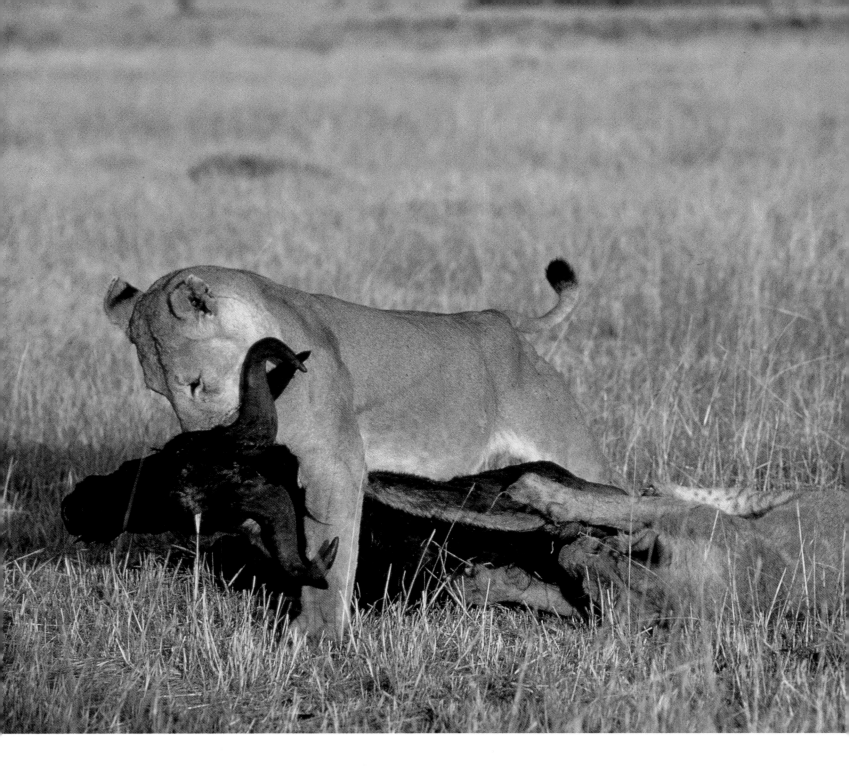

shoulders which aid in grappling prey. The jaws are very strong indeed and armed with long canine teeth. The lion's bite is strong enough to dispatch large prey animals like the wildebeest. The tongue is particularly rough, with strong backward-pointing tubercles, which grip prey when feeding and help remove ticks and fleas from its own skin when grooming.

The male lion is much larger than the female, often up to 50 percent heavier, and is easily recognised by its impressive mane. This large size gives males the advantage at a kill, as they push their way in to steal an animal caught by the smaller females. Many males survive solely on food caught by females and never attempt to catch anything themselves.

The usual role of the large males is to defend territories against intruders, leaving the females to do the hunting.

Lions are unusual amongst large cats in the way they regularly cooperate during a hunt. A pride of females will work together to isolate and then bring down a prey animal. Hunting usually takes place at night, especially on the open plains where vegetation is short and provides little cover.

A group of lionesses will spread out to encircle the prey, approaching it to within about 30 metres (100 feet) before making the final charge. When they are close enough the prey animal will be hit with the lionesses' huge paws and knocked down or jumped

A pair of lionesses in the Masai Mara game reserve tackle a wildebeest. This large animal may have been able to evade one lioness, but two can easily overcome it. The ability of lions to cooperate whilst hunting has enabled them to become the most efficient of the hunters of the open plains.

upon before being killed by a bite to the neck. About one in every four charges will be successful.

All members of the group join in to feed, with some frightening-looking squabbling occurring if the group is large. This is usually the stage at which the large male lions muscle in to eat their fill, and there may be troublesome hyenas to contend with as well. Lions normally tackle large prey, allowing whole social groups to feed at the same time, but they will sometimes take small animals if the opportunity arises.

Lions can breed at any time of year, but within one pride most of the females may give birth around the same time. They rear

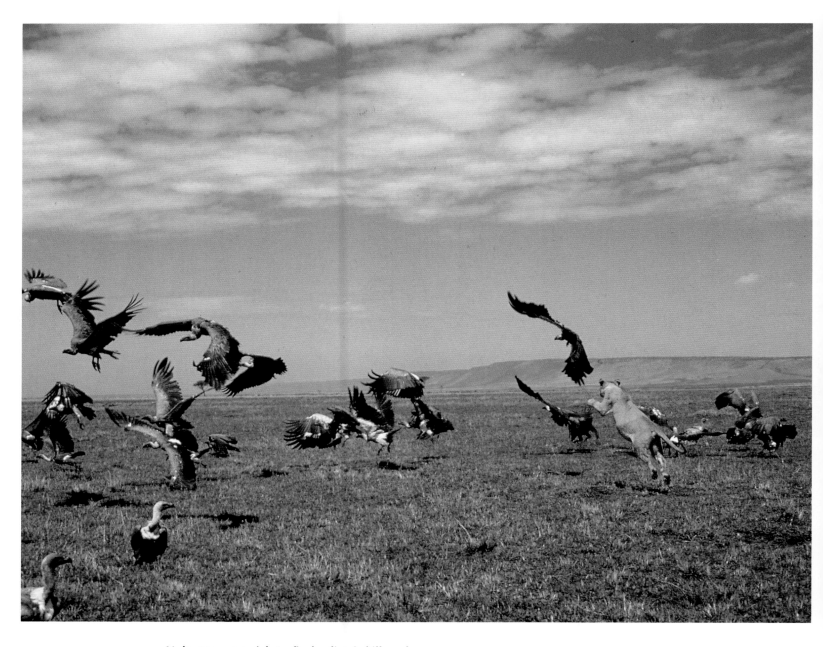

Vultures are quick to find a lion's kill and move closer and closer in order to start cleaning up the carcase. Here it has become too much of a temptation for this young lion who has dashed amongst them in the hope of an easy meal.

A snarling lion advances through the bush in the Masai Mara game reserve in Kenya. The prominent mane of the male lion is a unique feature in big cats; it may serve to make the large head of the lion look even more fearsome.

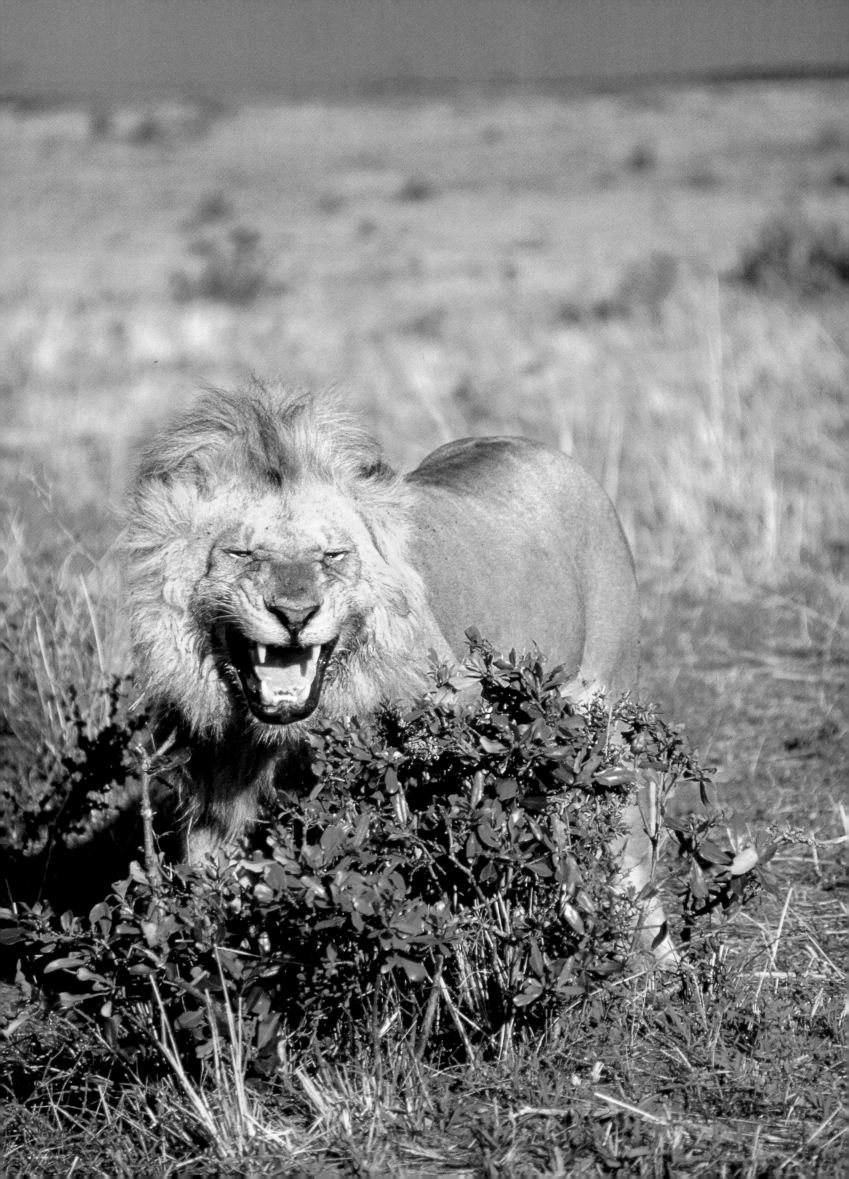

A young elephant caught at a water-hole is soon dispatched by the lion's powerful bite around its neck. The sheer weight and strength of the lion is sufficient to overcome the baby elephant even though it is larger than the lion.

their cubs together and even cooperate with suckling each other's young. The average litter size is three cubs, and they will remain with the mother to suckle for six months, although they can eat small amounts of meat from about three months of age. A female will be ready to produce her next litter when her cubs are about two years old, although the chances of all her young reaching that age are very small. About 80 percent of all lion cubs die before reaching the age of two.

Territories are strongly defended, usually by the males, who mark key points with urine, patrol the boundaries, and roar terrifyingly at night. Intruders who approach the boundaries are driven away, but sometimes fights

break out with one lion retreating with severe wounds or often even killed.

Within the territory, the pride may consist of up to twelve related adult females and their young and up to six adult males who are probably related to each other but not to the females. Depending on the nature of the land and the abundance of prey animals within it, the pride may cover an area of up to 400 square kilometres (155 square miles). Some territories, however, in areas where food is abundant, may need only about 20 square kilometres (8 square miles) in order to survive.

One puzzling aspect of lion behaviour, which is now more fully understood, is male

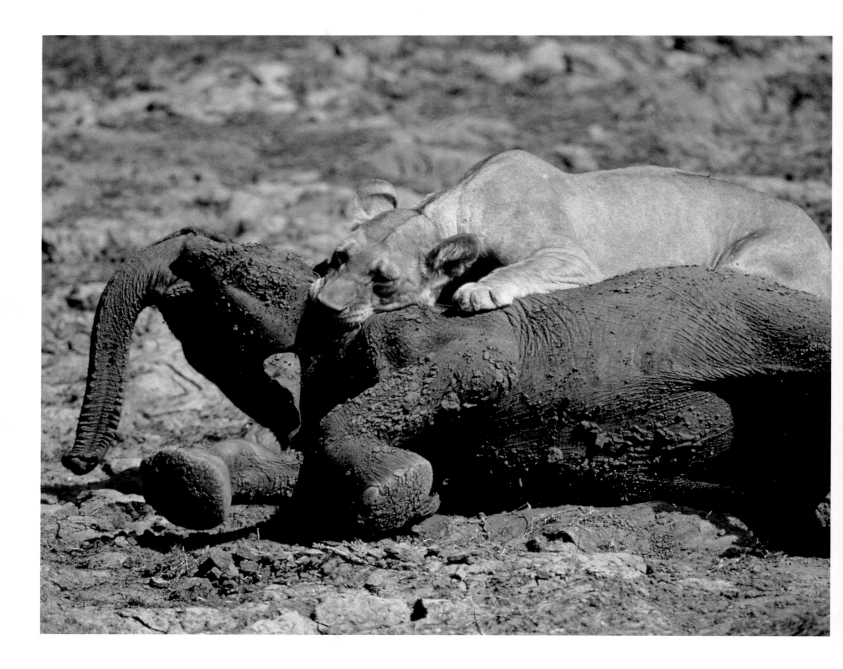

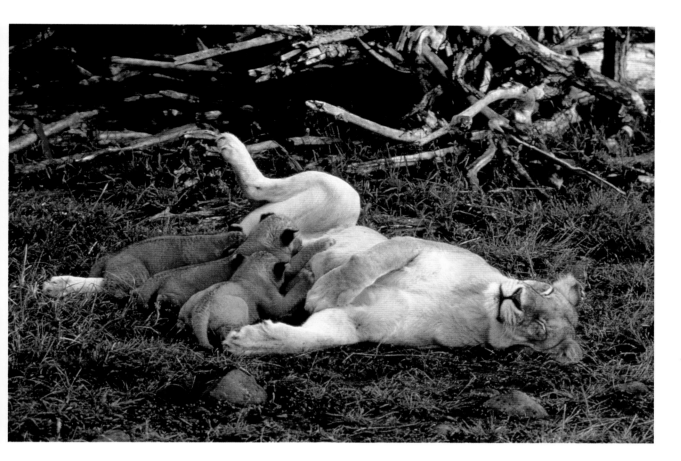

A lioness relaxes in the sun as she suckles her three cubs. The male lion will play no part in the raising of the young, and will actually be driven away by the female if he tries to approach them.

lions' habit of killing cubs. Attacks by males are the main cause of death in young cubs, and they are likely to be attacked if a rival male takes over a pride, driving out the original males. He will kill most of the small cubs, thus stimulating the females to breed. The resulting offspring will, of course, then be his own and will have a better chance of survival than if there were other, larger cubs competing with them for food.

Cheetahs

The cheetah is the fastest land animal, and can sprint at about 100 kilometres per hour (60 miles per hour). Thus they are superbly adapted to life as hunters on open grassland. Normally solitary, the cheetah lies in wait for an opportunity and then stalks, using whatever low cover is available, until it judges the moment right for the final sprint toward its prey. It usually approaches to within 30 metres (100 feet) before making the final attack. Most chases last for around twenty seconds, and only about half of the attacks are successful.

The cheetah favours prey species such as the Thompson's gazelle, which although

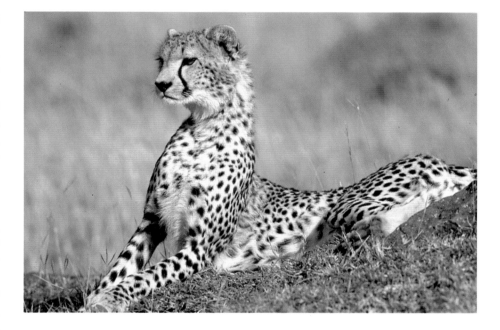

An alert cheetah, neck stretched for a better view, prepares to run after its prey. It will wait until the right moment before making its high-speed dash.

With a final surge of speed, an adult cheetah lunges at a Thompson's gazelle and brings it to the ground. It will now change its grip and bite the gazelle around the neck to suffocate it.

very fast and agile itself is small enough to be brought down with a final jump. The cheetah usually kills its prey with a long, suffocating bite to the throat; it is able to maintain this grip and still breathe due to specially adapted nasal passages, which allow air to flow even as it is holding tightly onto its prey.

Although cheetahs inhabit the same open grassland as lions, in addition to other predators like hyenas and wild dogs, their great speed and agility enables them to tackle different prey without competing with potential rivals. Cheetahs are very slim and long-legged and are easily able to creep up on prey unnoticed through quite short grass in places where lions and hyenas would be too exposed.

Sadly, the cheetah is now changing its habits as a result of the popularity of game-watching safaris in East Africa. If a cheetah is spotted with prey, it is very likely to attract a number of vehicles full of tourists with cameras, all of whom will want to take photographs. This sort of disturbance has led to cheetahs hunting at dusk and dawn in some areas, when the tourists are back safely in their game lodges. Unfortunately, when there is just too much disturbance, they abandon their kills and leave them to the hyenas.

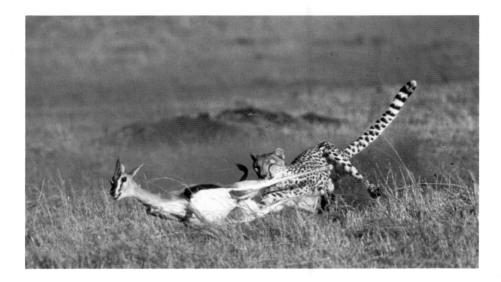

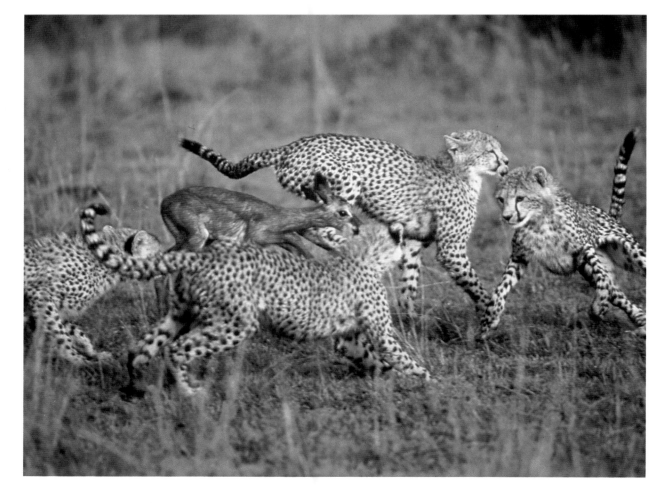

Four cheetahs tackle a young impala which has no chance of escape amongst these agile hunters. Cheetahs often cooperate to hunt, especially when young.

A nine-month-old cheetah cub practises tree-climbing, a habit normally confined to leopards. This adventurous play is part of the learning process in a young animal. The young cheetah will have to look after itself when its mother soon abandons it.

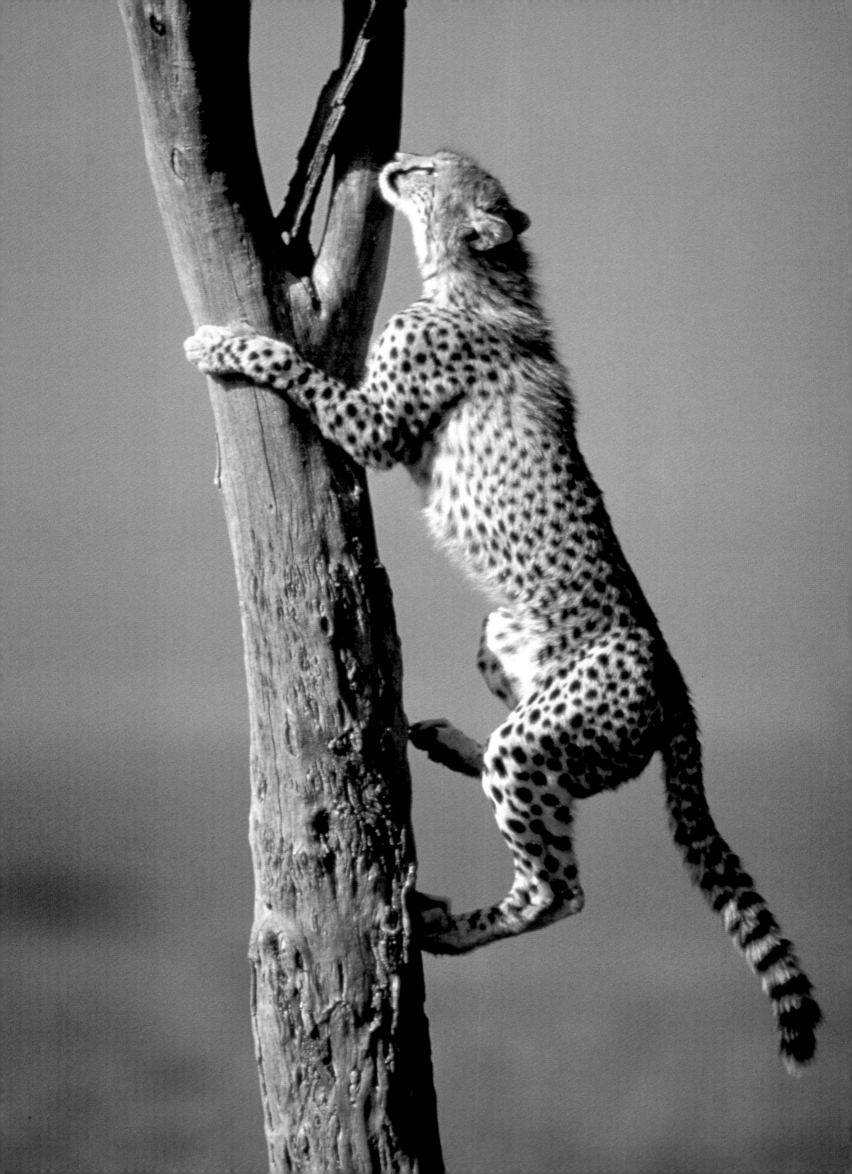

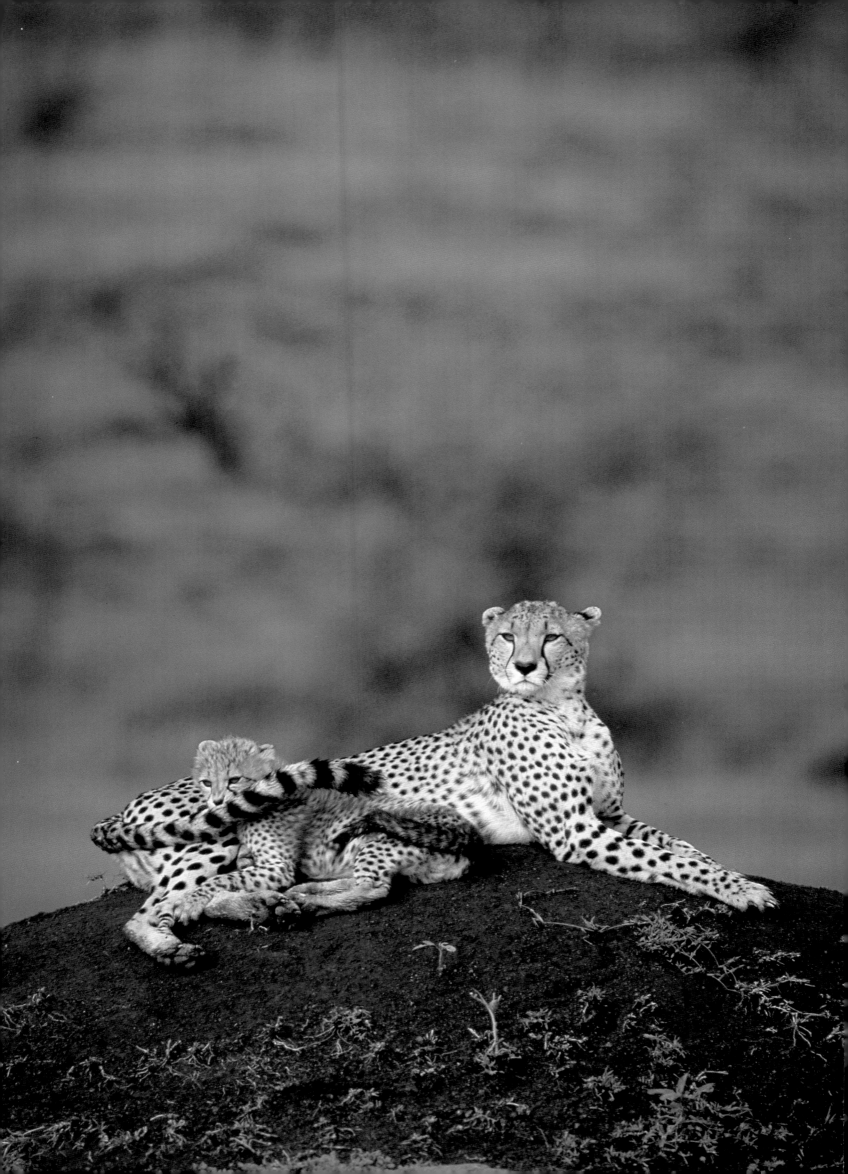

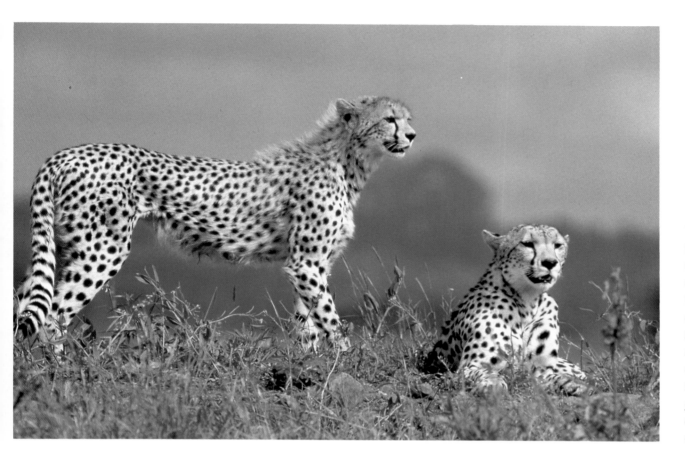

Two young chee-
tahs wait for their
chance to attack
a prey animal.
When first aban-
doned by their
mother they often
remain together,
cooperating to
find food, but
gradually they
drift apart and be-
come more solitary.

Four cheetah cubs
require a lot of
food, and in a poor
season the female
may not be able to
cope. As a result
some of her cubs
may not survive.
These healthy cubs
are well-fed and
their chances for
survival are high.

A proud mother
cheetah cradles her
cub with her tail.
From her termite
mound lookout she
will be able to spot
danger in the form
of lions and hyenas,
and a potential meal
if a small gazelle
comes close enough.

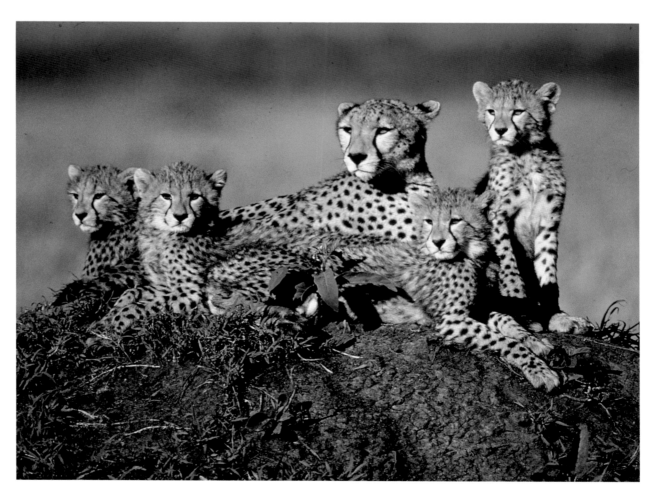

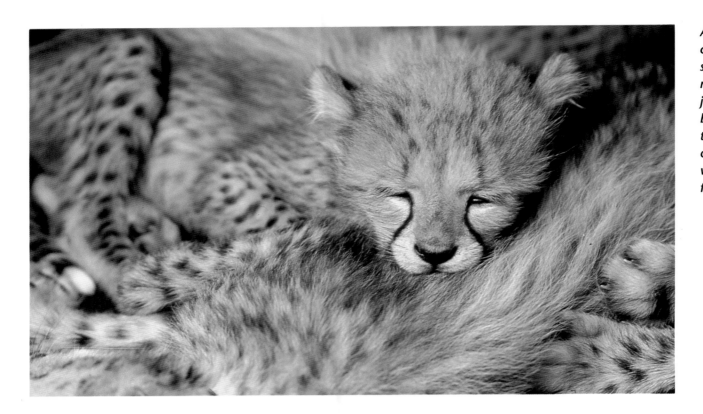

A two-month-old cheetah cub sleeps soundly after a meal. Its thick juvenile coat will be replaced by the more sleek coat of an adult when it is around four months old.

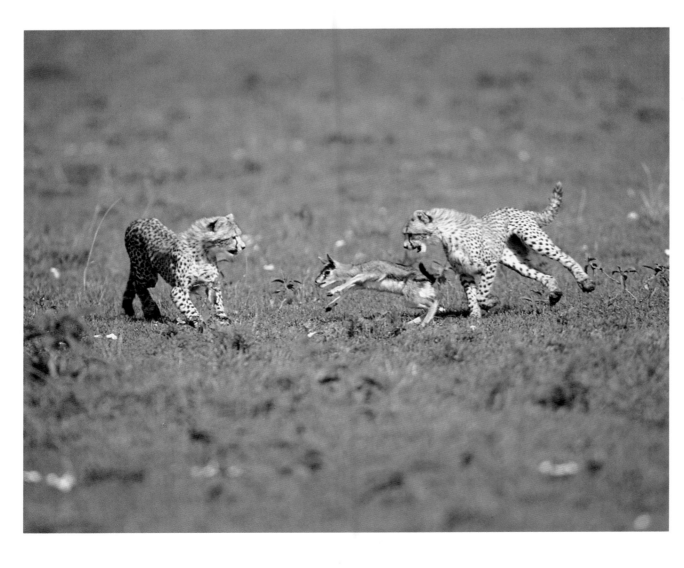

A pair of young cheetahs practise their hunting skills on a tiny Thompson's gazelle which has become separated from its mother.

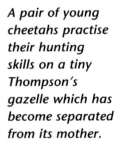

A six-week-old cheetah cub sits beside its mother still showing some of the pale juvenile coat, although its beautiful spotted adult coat is growing well. Not capable of hunting yet, the growing cub relies on its mother to make regular kills to provide it with food.

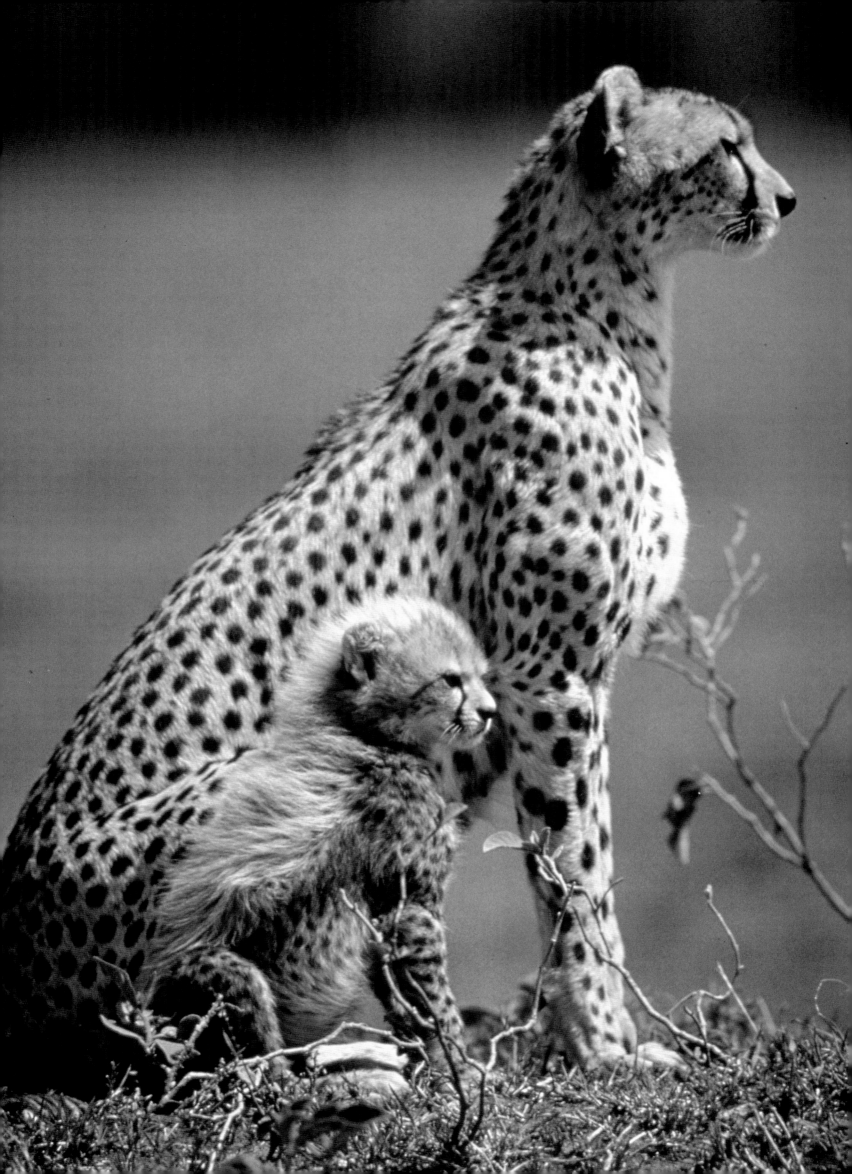

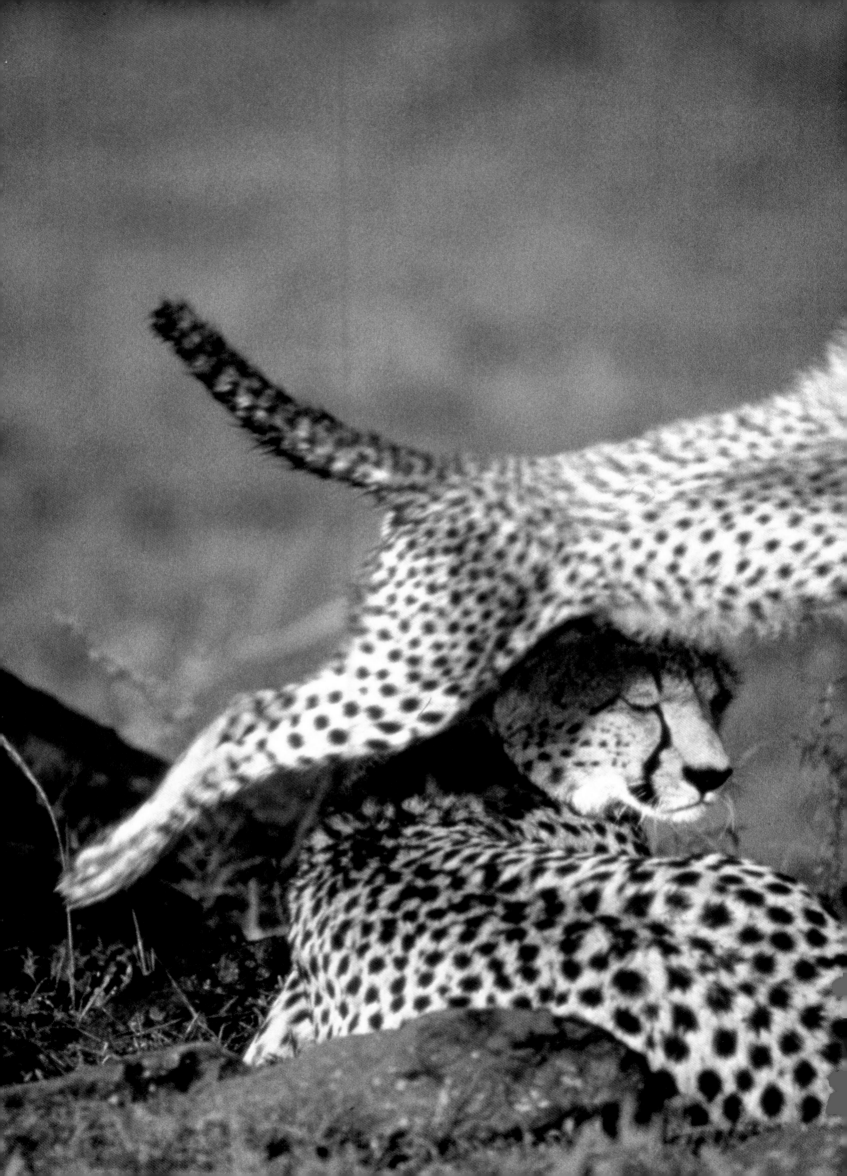

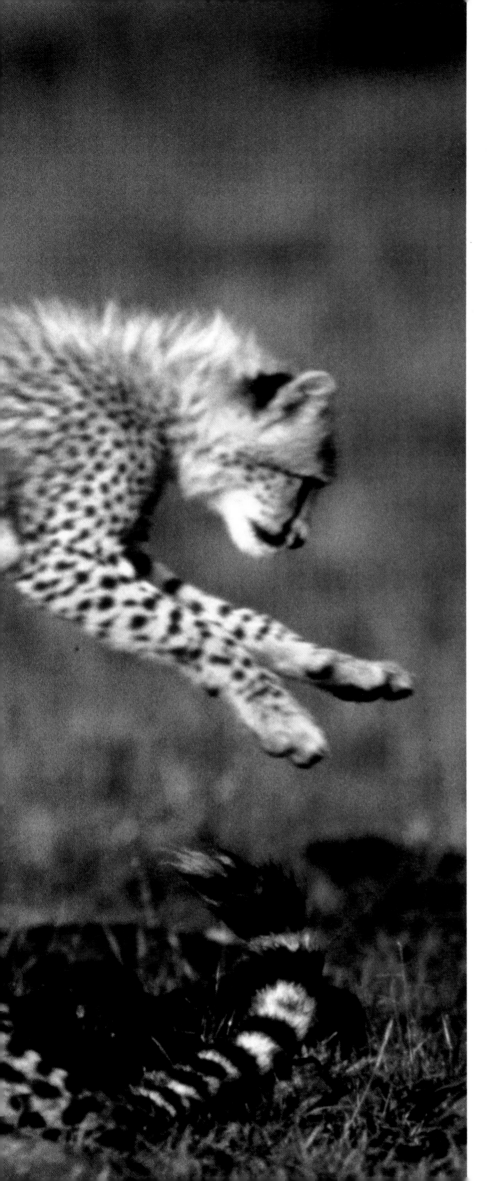

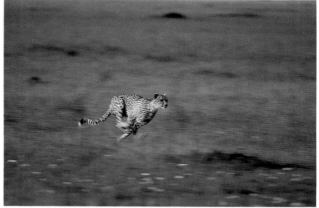

The cheetah is capable of tremendous bursts of speed and is considered the fastest land mammal; its acceleration during a chase is comparable to that of a sports car.

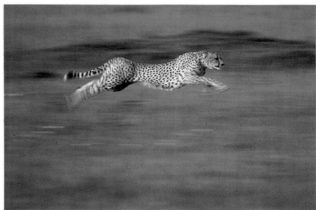

The cheetah's flexible spine and long stride enable it to run at a high speed; its claws, which are extended during the chase, give it extra grip on loose ground.

A playful cheetah cub jumps over its mother. The mantle of blue-grey hair shows that the cub is no more than three months of age.

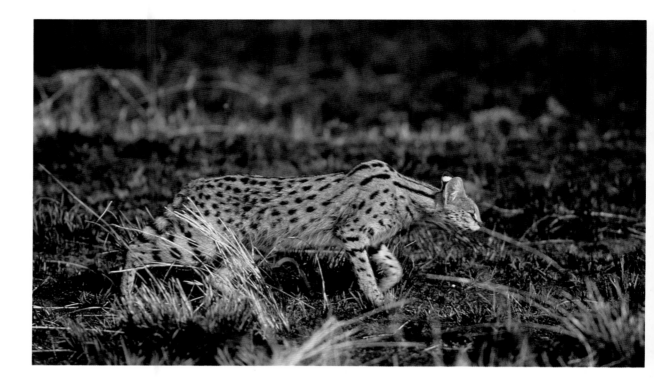

A serval moves with great stealth through short grass before pouncing on its prey. Its beautiful spotted coat, once prized by fur trappers, provides excellent camouflage in dry grassland.

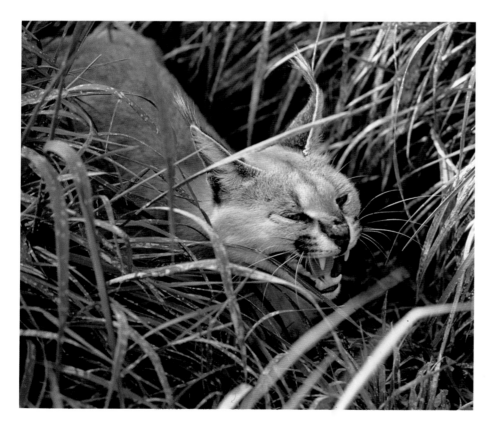

A caracal warns of its intention to pounce; its prey may be small rodents or even young deer. It is a fast runner and is able to knock down large prey by pouncing on it. Caracals are found in grassland, scrub, and forests in Africa and Asia.

Servals and Caracals

Two smaller species of cats also inhabit the grassy plains of Africa, taking far smaller prey species than the cheetah. The serval and caracal take many rodents, and the young of some of the smaller species of gazelle. The serval is most likely to be found near water, where it chases birds as well as mammals. It is quite a good climber but is more often seen on the ground. Its long neck, good eyesight, and long legs make it an adept hunter in long grass; it can pounce with great accuracy on small prey.

The caracal hunts mainly at dusk, but during very hot weather it will wait until nightfall, relying on its good eyesight and hearing to locate the small mammals it prefers. It also has very long legs to help it move easily in long grass, and it often runs after prey, pouncing on it at the last moment. Servals are restricted to the grasslands of Africa, but the caracal is much more widely distributed, found in Africa, Arabia, and north-west India.

The serval is a slim, long-legged cat of the open African savannah, and it is usually found near water. Its large ears, long neck, and good eyesight help it to locate small birds and mammals in dense vegetation.

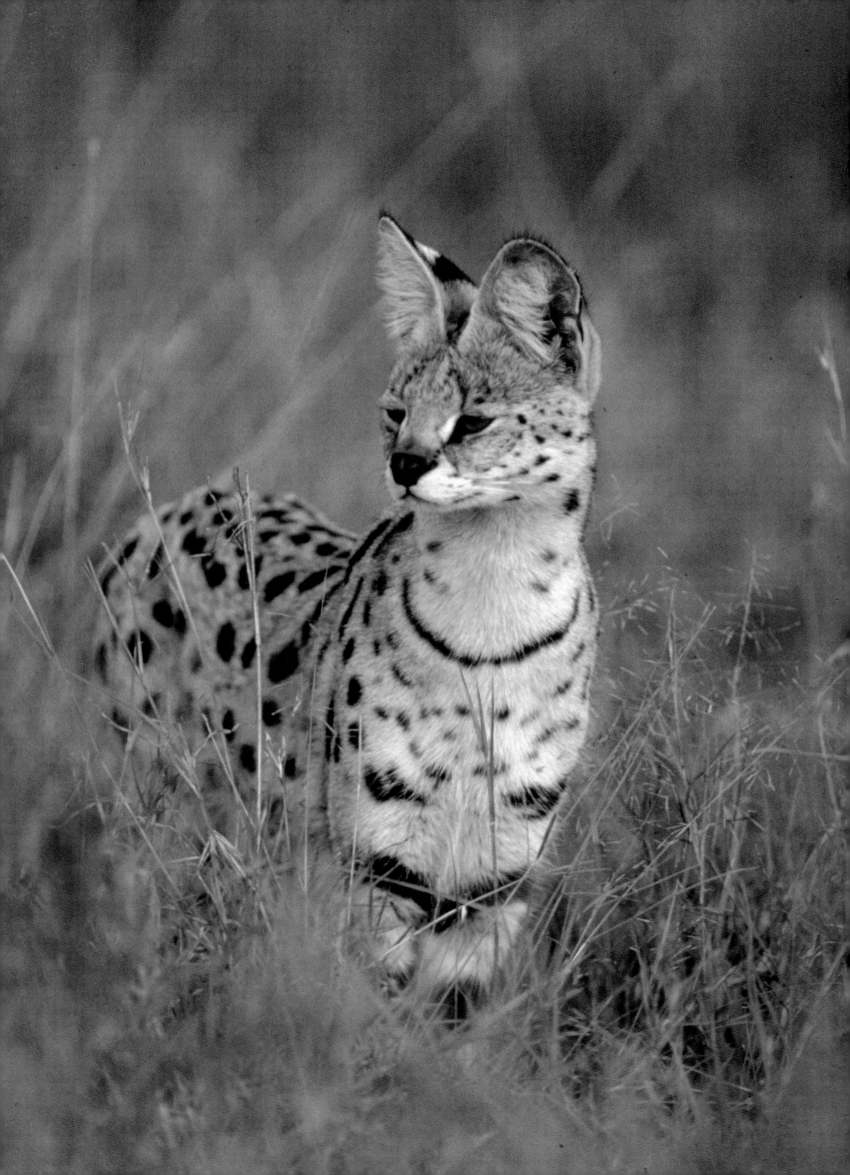

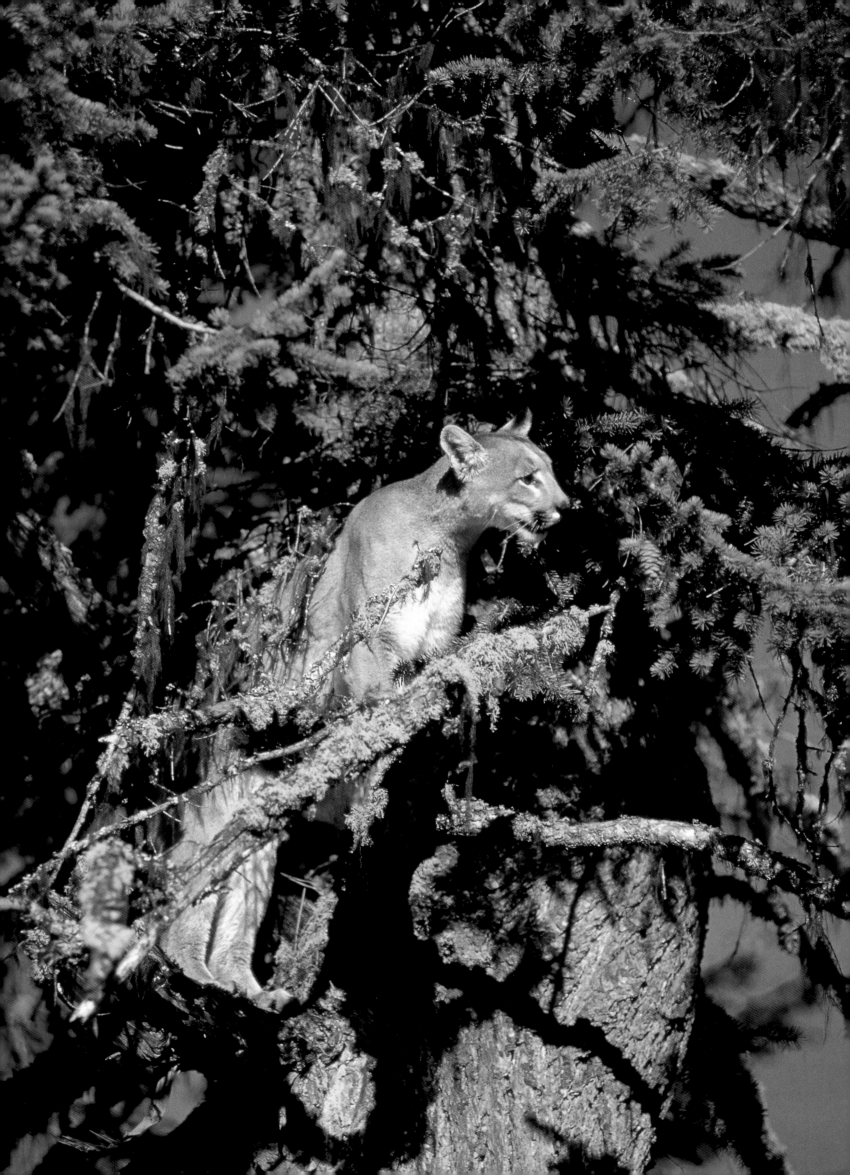

THE NORTHERN FORESTS

Life in the cold northern coniferous forests can be tough in winter. Prolonged low temperatures, deep snow, short daylight hours, and scarce prey make life difficult even for superb hunters like the big cats. Add to the natural hazards the constant threat from fur trappers, and life in these forests can be a real struggle.

In summer the picture is rather different as the forests are vibrant with life. Migrant birds will have returned to nest, small mammals will have awakened from hibernation and be feeding on the forest floor, and the cats will have ample food once more. There will be no snow to make movement difficult and the long hours of daylight aid in hunting.

Three species of cats are widespread in these northern forests, and they have one common characteristic which enables them to survive. The mountain lion, the lynx, and the bobcat all maintain and defend their own hunting territories, thus ensuring that there is an adequate supply of food throughout the year.

Mountain Lions

The mountain lion is a hunter which is very well adapted to life in these forests. Although not comparable in size to the big cats of Africa and Asia, measuring at most less than 2 metres (6 feet) in length, it is a strong and agile hunter with the usual cat characteristics of good eyesight and hearing and excellent reflexes. It is the largest native cat in North America, yet it is endangered due to centuries of persecution.

A two-year-old female mountain lion threatens an intruder, showing her impressive teeth. Note the rough tongue, a special feature of cats that enables them to rip off small pieces of flesh.

A mountain lion demonstrates its tree-climbing skills in a northern United States forest. During the day it will remain hidden, emerging at dusk to hunt small mammals and deer.

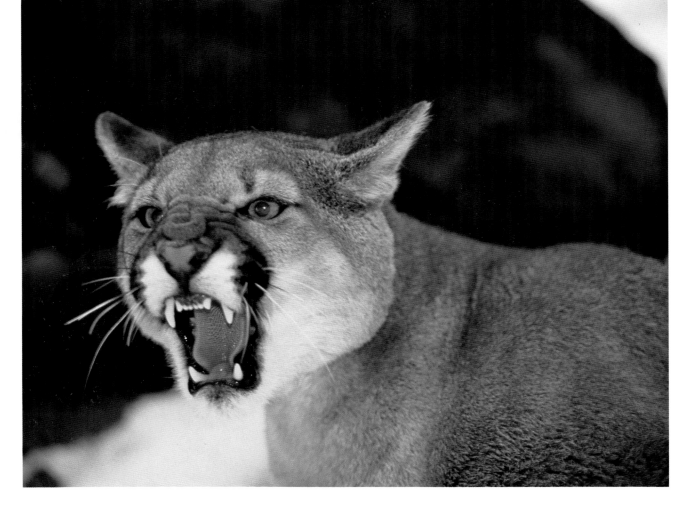

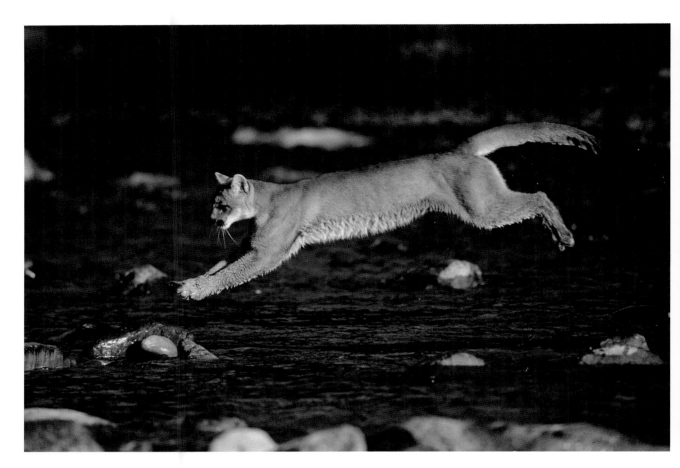

An energetic leap helps a mountain lion clear a stream. A fear of man, due to constant persecution, makes this a difficult animal to study in the wild.

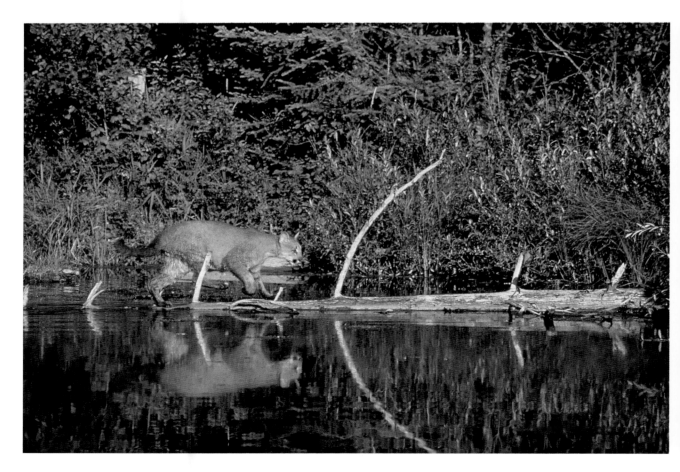

A mountain lion makes use of a fallen tree to cross a stream in a northern forest. This secretive cat is much persecuted by fur trappers and farmers. As a result, it is rarely seen during the day.

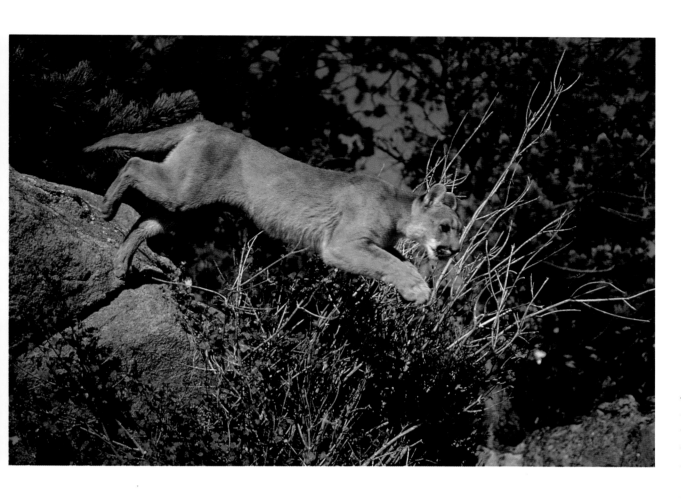

A mountain lion in its thick winter coat jumps from a rock to pounce upon its prey.

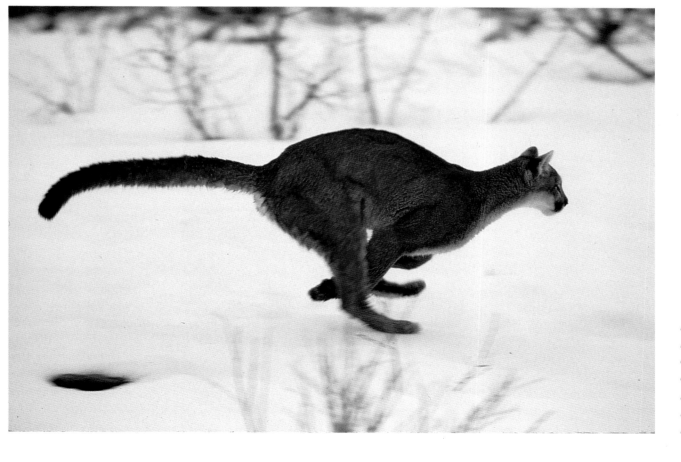

The mountain lion is capable of impressive bursts of speed in the open, enabling it to catch fast-running prey like hares.

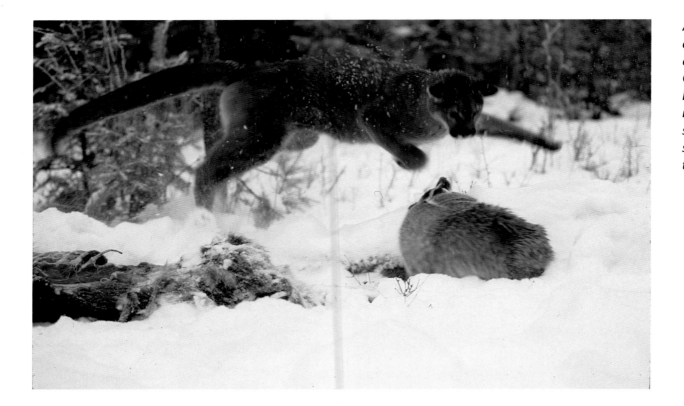

A mountain lion defends its kill with a threatening leap. Once a meal has been caught it needs to be consumed quickly before scavengers come to take their fill.

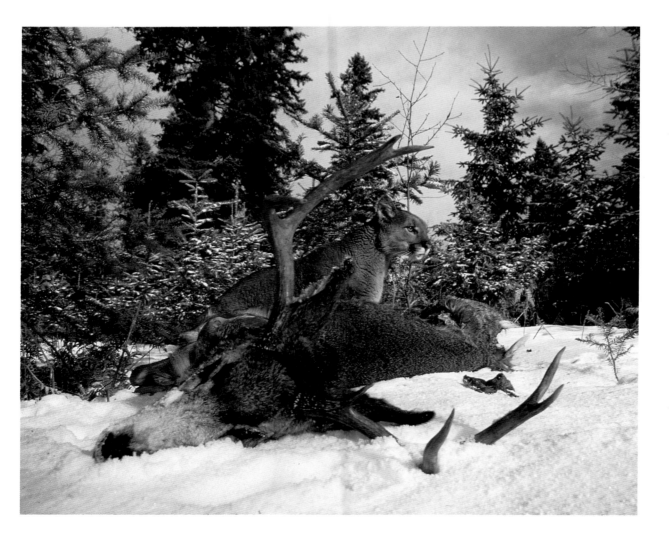

In harsh winter weather even large deer prey can be taken. Weakened by cold and hunger the deer are much easier to attack.

A mountain lion in its winter coat stands its ground beside a stream. It will hunt deer and smaller mammals in the winter, yet this can be a difficult time for it as fur trappers are more active during this season.

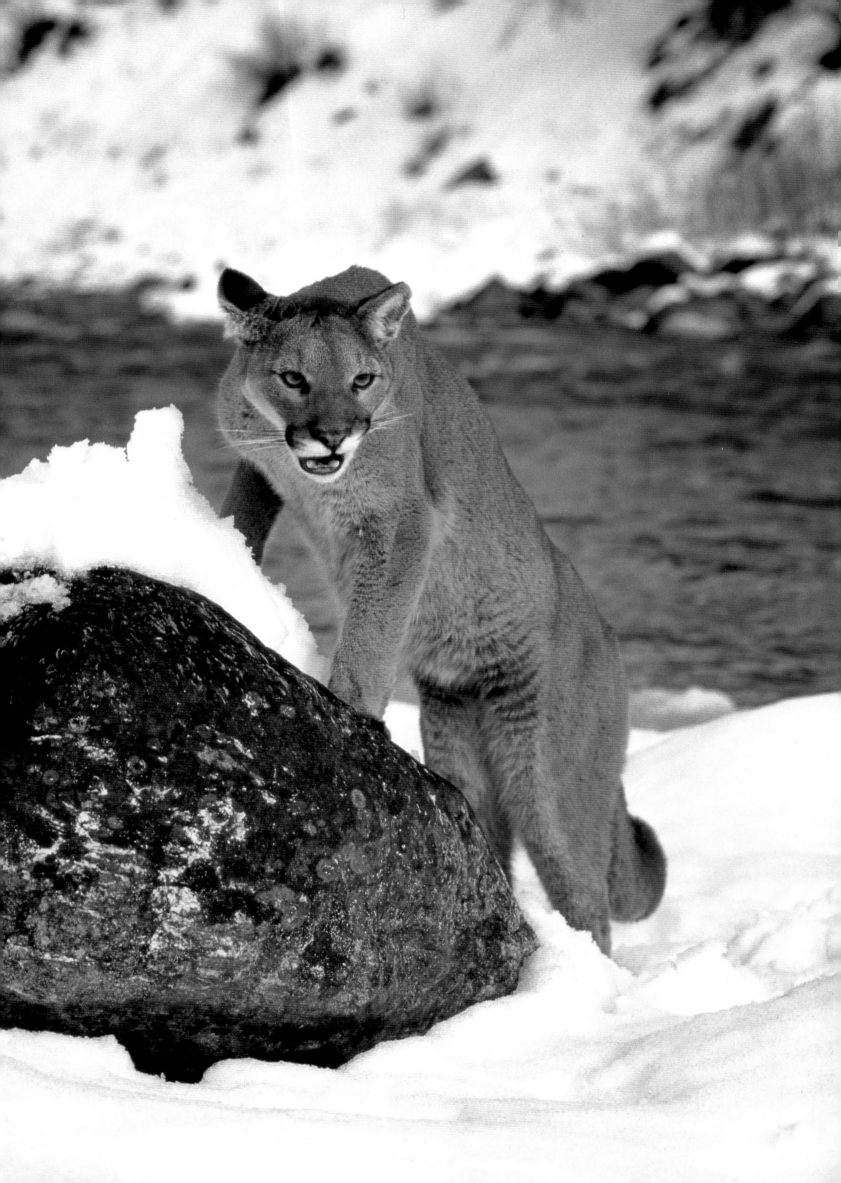

This very widespread species is known by various names in different parts of its range. In some parts of the United States it is called the cougar, and in others it goes under the name of puma—these are all one and the same species. It can be found over almost the whole of the United States and southern Canada, and as far south as Patagonia in South America. In the mountainous regions of the north-west United States it covers vast areas in search of large prey such as mule deer and elk.

The mountain lion lives a mostly solitary life, and even in winter when deep snow forces the deer, and therefore the mountain lions, down to lower altitudes, their hunting territories rarely overlap. Usually the males occupy larger territories than females and may include several females' ranges within their own. Encounters between rival males are rare, thus minimising the risk of dangerous fights. Constant scent marking of the edges of territories and occupied dens ensures that each animal is aware of the movements of the others.

Lynx and Bobcats

The lynx and the bobcat are very similar species of smaller cat found in North America. They grow to an average body length of around 1 metre (3 feet). Both are short-tailed, stocky, and well-adapted to survival in harsh environments. They are unlikely to be found together, however, because of their different habitat requirements. The lynx inhabits the cold northern forests and thick scrub of the far north, whilst the bobcat is always found in more southern regions, and always near trees or scrub. In addition to its North American range, the lynx also occurs in the wilder regions of Europe, from Spain to Scandinavia and east into Siberia.

The lynx is very much at home in the cool northern forests, and its coat of thick but

For its size the lynx has huge paws, making it an efficient climber and a fast runner.

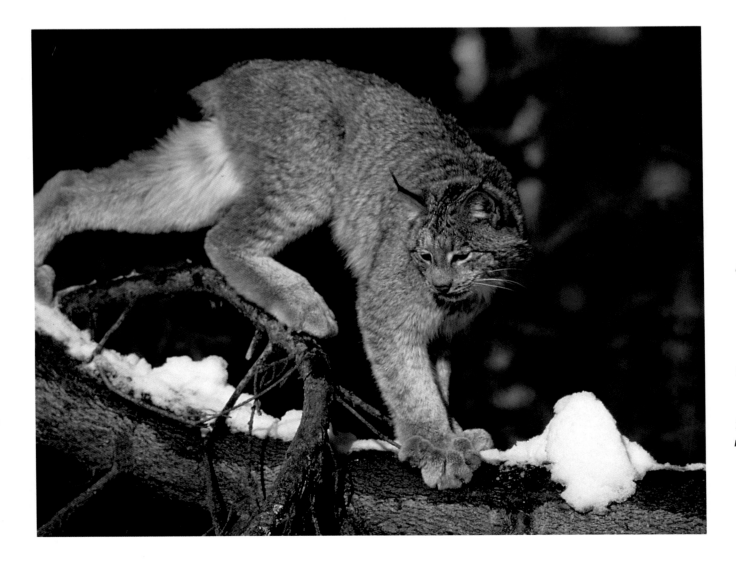

The lynx is usually solitary and has nocturnal habits, so it is not often seen. It hunts through forests and scrub at dusk, looking for small mammals and birds. Its excellent hearing makes finding prey in the dark an easy task.

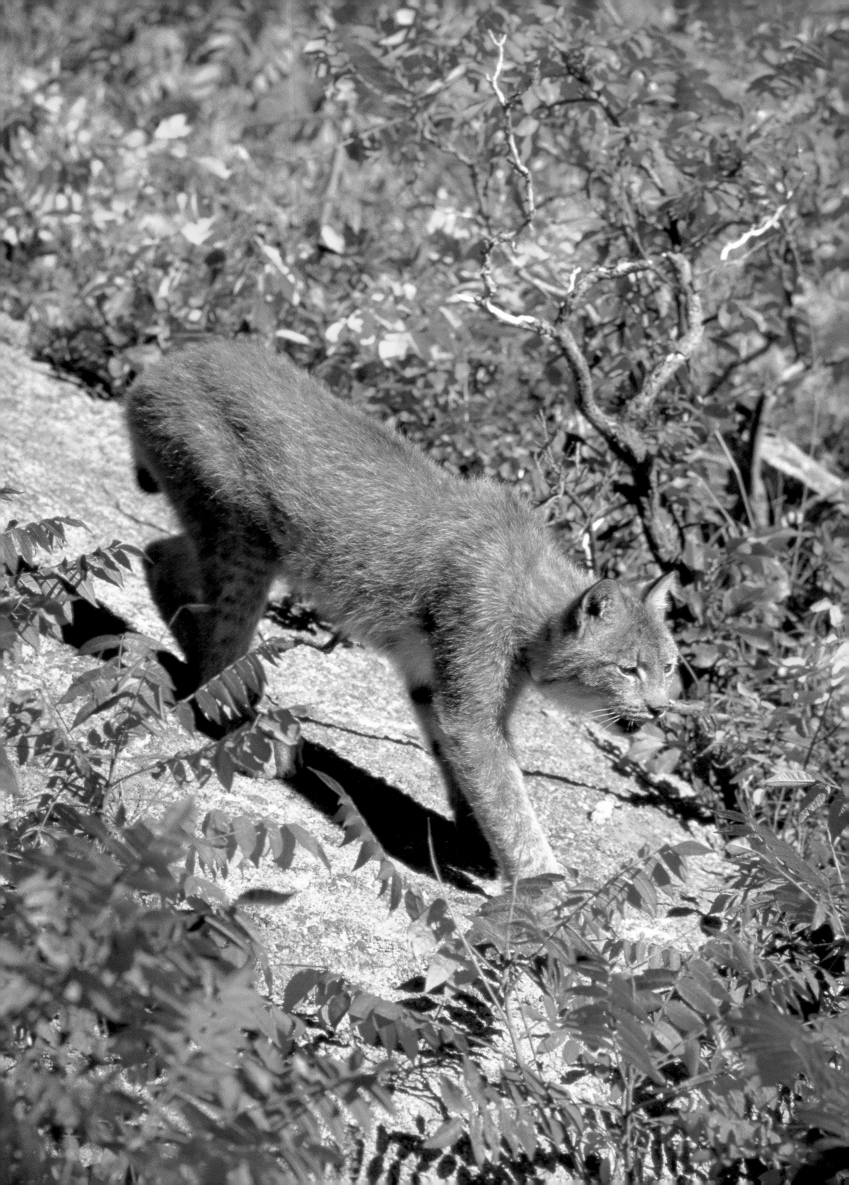

short brown-grey fur helps it merge with the background of mosses and lichens on the forest floor. In different parts of its range the coat varies from almost plain to darkly spotted. It is able to move silently through the forest as it stalks its favourite prey, the snowshoe hare. Unusually for a cat, the lynx has a very short tail, but it shares all the other typical characteristics, and has the usual impressive array of claws set into its huge paws. It also has very prominent ear tufts, and apparently has exceptionally keen hearing.

Lynx are able to locate small prey animals beneath snow and in near darkness in the northern winter. They are common in North America and in the forests of northern Europe where winters can be severe; they may have to cope with temperatures as low as -57° Celsius (-70° Fahrenheit). A lynx has long legs to help it travel through deep snow, and its foot pads are covered with a dense layer of thick fur. Its short tail may be a useful adaptation to the cold also, as it reduces the surface area of the body and thus cuts down on heat loss.

Although similar at first glance, the bobcat differs from the lynx as it has a much more spotted coat. This is to its advantage in the denser vegetation of the rocky habitat it

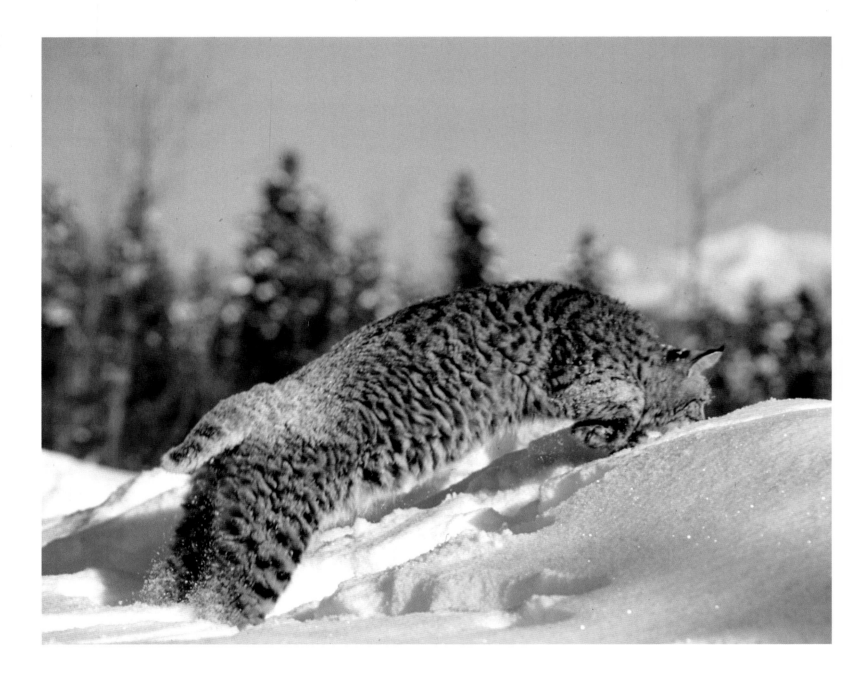

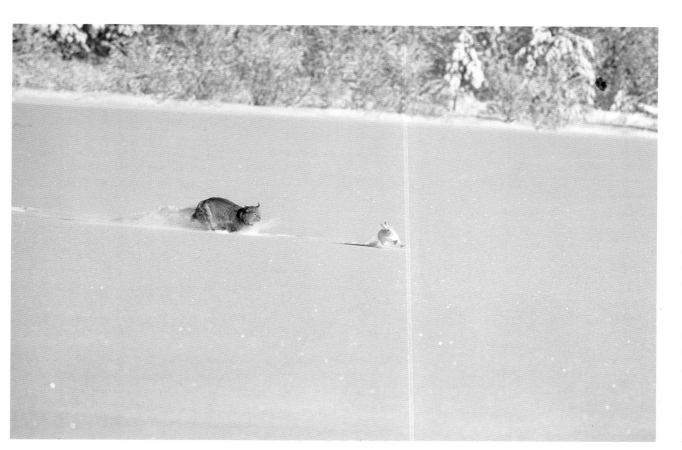

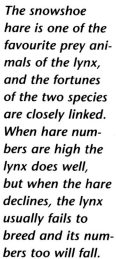

The snowshoe hare is one of the favourite prey animals of the lynx, and the fortunes of the two species are closely linked. When hare numbers are high the lynx does well, but when the hare declines, the lynx usually fails to breed and its numbers too will fall.

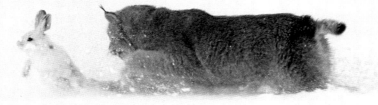

Even a fast runner like the snowshoe hare is no match for a lynx, which is fast and agile enough to catch it out in the open. The lynx has much longer legs, giving it the advantage in soft snow.

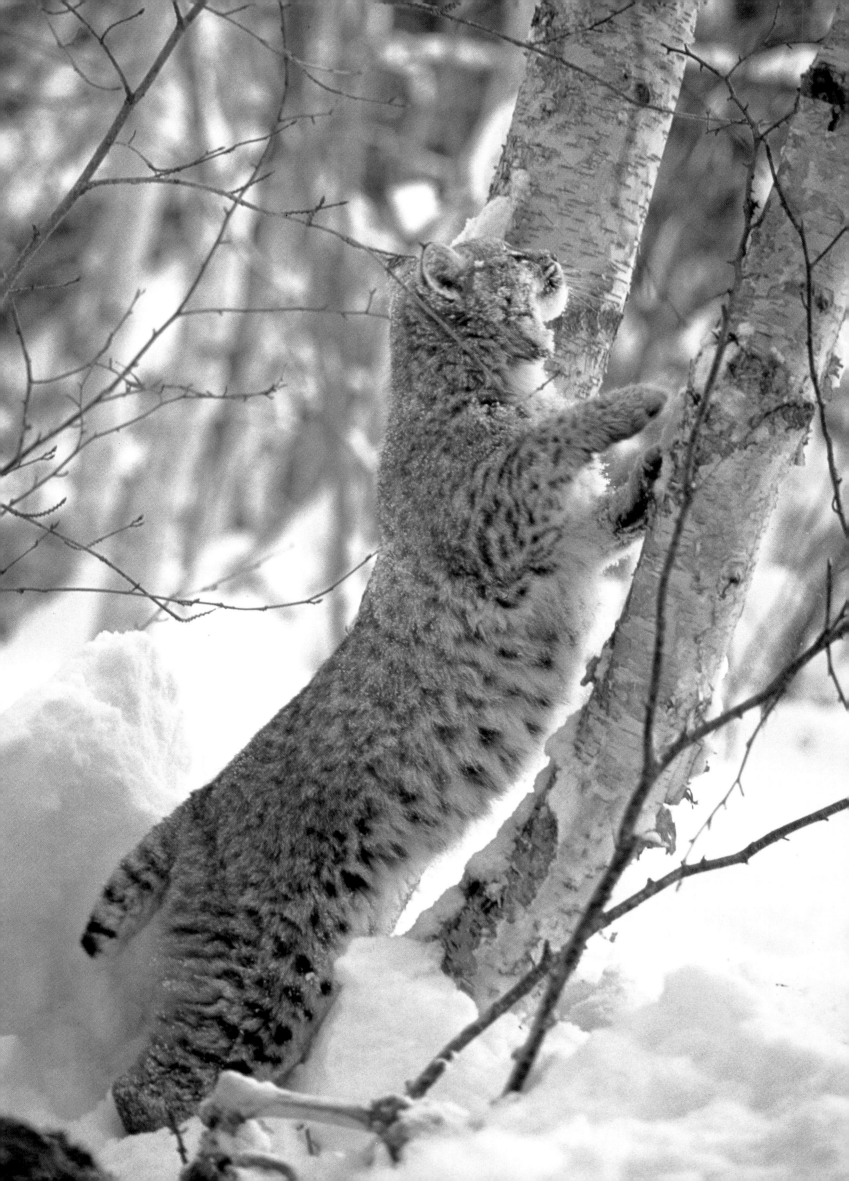

prefers. Its normal prey is the cottontail, which it hunts by sight rather than sound; thus it lacks the prominent ear tufts of the lynx. Although similar in many respects, these two cats rarely compete with each other, as each shows subtle adaptations to its own habitats and chooses different prey species.

As with the larger cats like leopards and tigers, the size of the home ranges of the bobcat reflects the abundance of food. When rabbits are plentiful the bobcat does not wander far, but in times of food shortage their ranges may be extended and they may come into conflict with other bobcats. Females seem to require less land area than males, and the home territories of one male may include the home territories of two or more females.

The ranges of rival males rarely overlap, and they are marked by strong-smelling piles of feces and other secretions. Urine spraying along favourite hunting routes is, as displayed by most big cats, one of the most common methods of warning other bobcats to keep away.

Following page: A mountain lion uses a dead tree to survey his mountain territory; in winter it will follow deer down to lower altitudes and may then be found closer to human habitation.

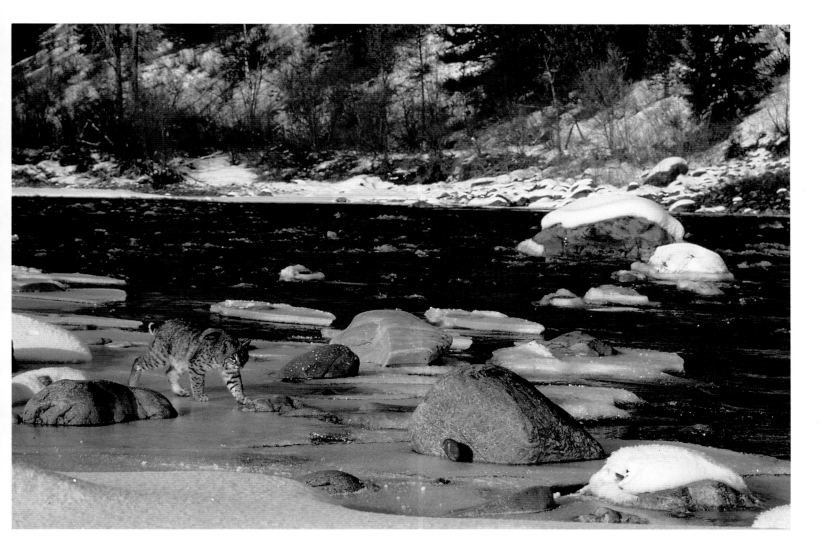

A bobcat cautiously approaches some carrion on a frozen river bank. When conditions are harsh a bobcat will take to scavenging if not able to catch its own prey.

The bobcat is easily recognised by its short tail and spotted coat, and in winter it may be seen hunting during the short daylight hours.

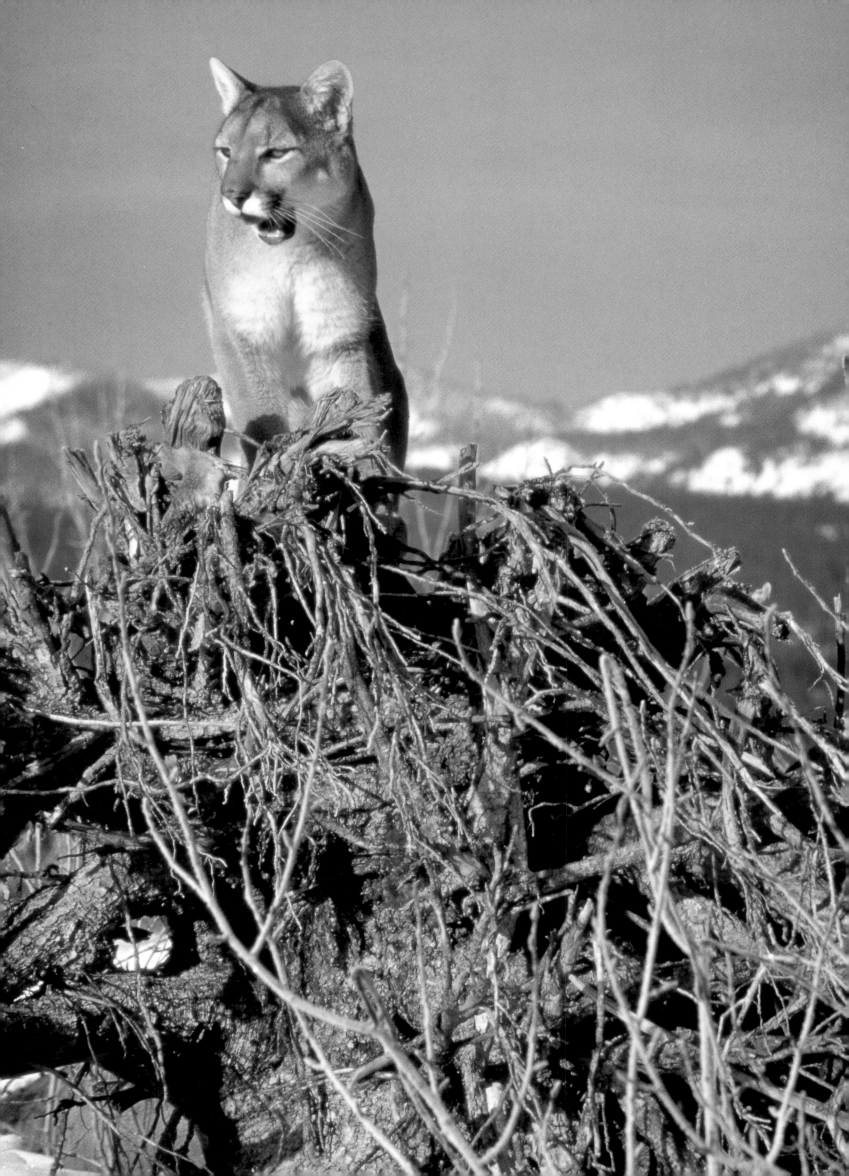

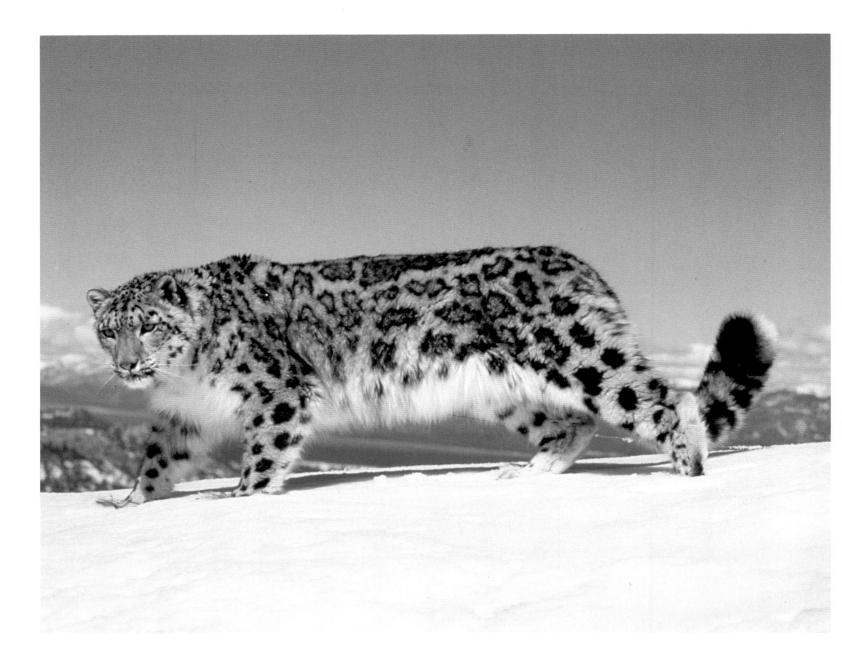

Snow Leopards

High above the tree line in the Himalayas lives the rare and elusive snow leopard. Little is known about this shy, mostly nocturnal species except that it covers huge areas of the mountains in its search for ibex, wild sheep, and sometimes domestic livestock.

In summer, when they wear their fine summer coats, they range high into the mountains in search of marmots and other small mammals; the wild sheep will have lambs then which may make easy prey for their own cubs to feed on. The intense cold and deep snow of winter will drive the snow leopard down into the steep valleys where it may have to resort to taking domestic stock.

The winter coat of the snow leopard is thick and attractively marked. Even the pads of the feet are covered with fur in order to protect against the snow and help distribute the animal's weight when walking. This remarkable and very rare animal is relentlessly hunted for its beautiful coat, and is in great danger of extinction.

Siberian Tigers

The forests of Siberia are home to the largest and rarest of the big cats. The mighty Siberian tiger is now reduced to around two hundred animals. As with other big cats it has been persecuted relentlessly, and it has also suffered from the loss of

much of its habitat. Without great tracts of forest to roam and hunt in, it is forced to seek food in agricultural land, leading to inevitable conflicts with humans. As always it is the tiger that suffers, so this magnificent animal may not be able to survive much longer in the wild.

Big Cats and Man

Man's relations with big cats have been uneasy for as long as the two have come into contact with each other. The cats have always been feared as dangerous killers of people, and they have been perceived as threats to domestic stock like cattle. In addition, the animals are hunted as sporting trophies and they have been killed by the tens of thousands for their fur.

The hunting skills of the big cats are legendary. Tigers in India, lions in Africa, jaguars in South America, and mountain lions in North America have all been incorporated

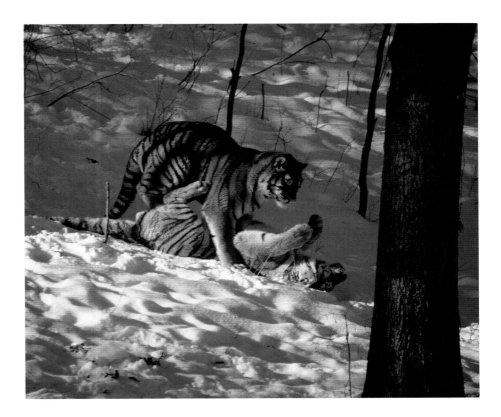

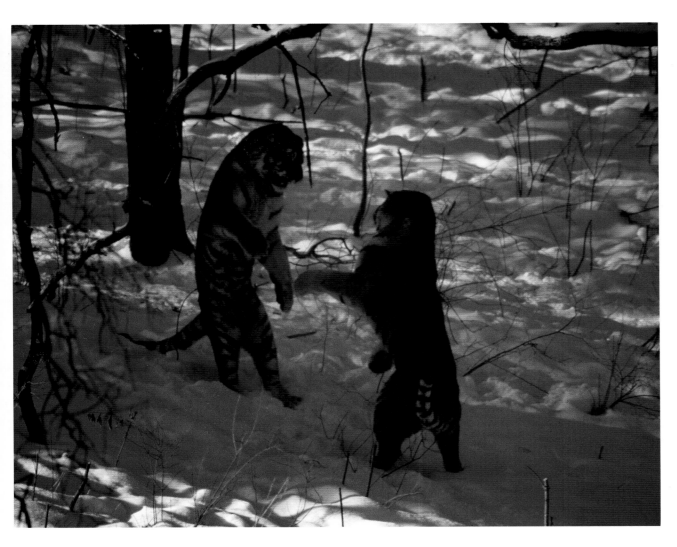

A pair of Siberian tigers, largest of all the cats, play in the winter snow of a northern forest. Normally solitary, a mated pair will remain together for short periods.

Play is important in young tigers as they learn the skills they will need as adults to hunt for food and defend themselves. These mock battles usually do not result in any serious injuries.

into myths and rituals, and literature and artwork, for their prowess as hunters is envied by humans. Wearing the skins of these animals was thought to confer some of the animal's strength and power to the humans who wore them.

It is only in relatively recent times that the importance of the big cats as predators has been fully understood. Their role in keeping populations of grazing animals at levels which the environment can support is now seen as crucial. Predators will never outnumber their prey species; if the prey animals decline, so too do the predators.

An abundance of hunters means that there is an even greater abundance of the animals they prey on. Predators will attack prey animals that are weak or sick. They often take very old animals that are no longer able to feed themselves, or they take inexperienced young which have not yet learned the skills needed for survival. They certainly do not kill simply for the sake of it and they do not take a surplus of food. The effort required to kill an animal cannot be wasted in killing for fun.

A lynx spreads its claws in the final moments of a chase before pouncing upon its prey.

In Africa there was a desire amongst big-game hunters to kill animals belonging to the so-called big five category. These included the elephant, the rhinoceros, the buffalo, the lion, and the leopard. A person who killed one or more of these was thought to be an excellent hunter; he or she would have the animal's skin to keep as a trophy and would be able to tell stories about his or her adventures. For no other reason than satisfying someone's pride, magnificent animals, amongst them lions and leopards, which are essential to the well-being of their entire habitat, were ruthlessly persecuted. As a result, in many parts of their range big cats became scarce and even died out completely.

Cats have been persecuted for their beautiful furs for centuries. At first the skins were worn by chieftains and those who hoped to prove their own strength as an animal hunter. Later the skins of cats were used for warmth, to protect people living in cold climates. The emphasis changed again when the furs were made into fashionable clothes for people living in towns and cities. The

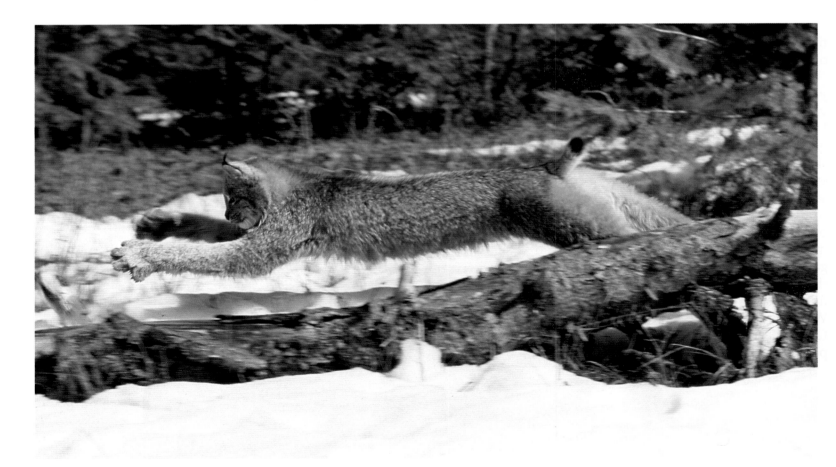

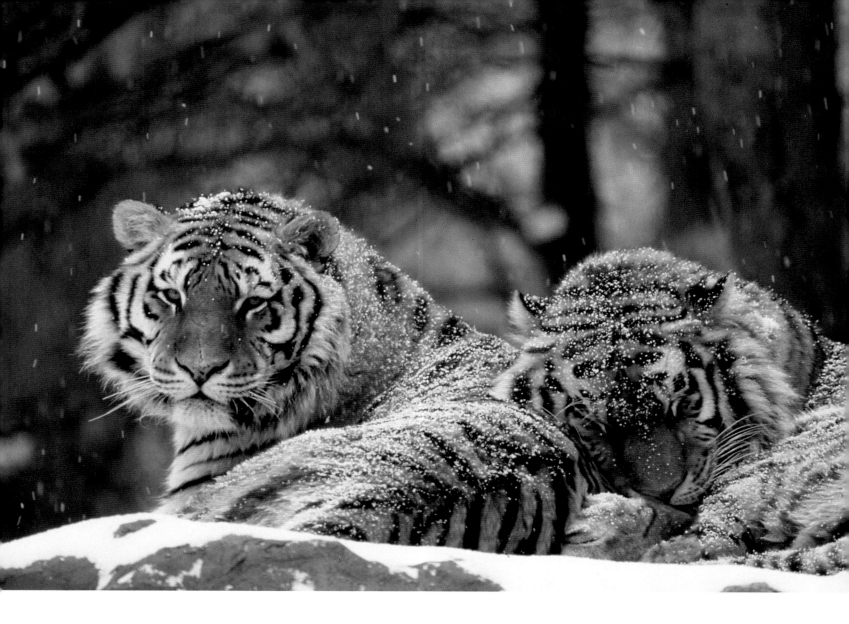

more attractive the animal's coat, the more in demand were their furs.

Huge numbers of cats are still killed every year in order to provide furs to satisfy human vanity. Figures for 1977–78 show that in the United States 85,000 bobcat skins and 20,000 lynx skins were taken. Many more beautiful skins were imported from South America and even further afield. The carnage, in order to satisfy the fur trade, is clearly severe. Immense numbers of cat skins are required by the fur industry because of the desire to match the markings when making a large garment like a fur coat. Wastage is high and the number of individual cats killed to produce one fur coat may be as many as twenty. When one species of cat is so scarce that the fur trade cannot be supplied with enough pelts, a new species is persecuted until it too becomes endangered.

The populations of large and medium-sized cats are systematically being reduced to levels where they may no longer be viable. Fortunately, many people realise that the furs look better on the cat than a human and are not prepared to accept the cruelty and ignorance involved in trapping and killing these animals. The cats' importance in ecosystems is too great to allow them to be wiped out by human greed.

A further very serious threat to the survival of the big cats is the destruction of their habitats, a problem which is particularly serious for the forest-dwelling species. Large-scale clearance of forests in tropical regions has left little room for large predators, which need to hunt over vast ranges.

On the bright side, many people rate very highly an encounter with a big cat in the wild, and are thus willing to suspend land development in these animals' ranges. It is now relatively easy to go on safari to places where the big cats may be seen in a natural state. Lions, for example, are worth more alive than they are dead in Africa because of the importance today of wildlife tourism. The drivers of safari vehicles will be handsomely tipped by their clients if they take them close

A dusting of snow falls on two magnificent Siberian tigers; their thick coats will keep the winter cold at bay. A male Siberian tiger holds the record for largest cat, weighing in at 384 kilogrammes (845 pounds).

to lions, cheetahs, or leopards. Similarly, viewed safely from the back of an elephant, an Indian tiger will provide useful revenue for villagers. Thus they tolerate occasional forays by tigers into their fields if they know that the same animal will attract high-spending tourists.

Also governments will compensate farmers whose livestock is lost due to predation in order that the populations of predators such as big cats can remain unharmed and continue to play a role their country's economy.

Excellent wildlife photography and filming have brought these big cats into people's homes more frequently in recent years. Much more is understood today about their lives and their important place in the natural world. Perhaps, through improved knowledge and an understanding of their complex lives, our future relationship with the cats will be far less uneasy.

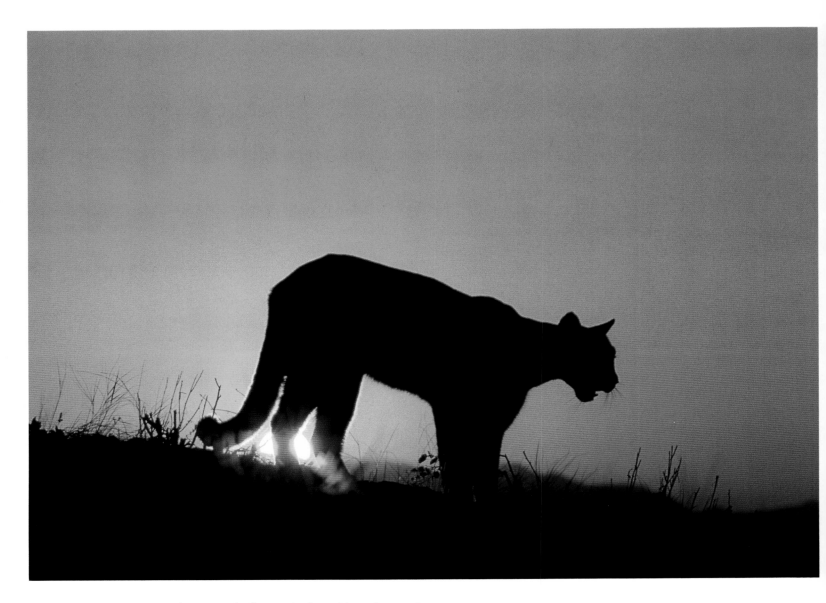

A mountain lion patrols a ridge at sunset, scenting the air for signs of prey. This is its favourite hunting time and, with its good eyesight, hearing, and sense of smell, it has the advantage over its prey.

With its mouth still stained with blood after a meal, a thick-coated lynx stands beside a mountain stream. It is a ruthless hunter of small birds and mammals.

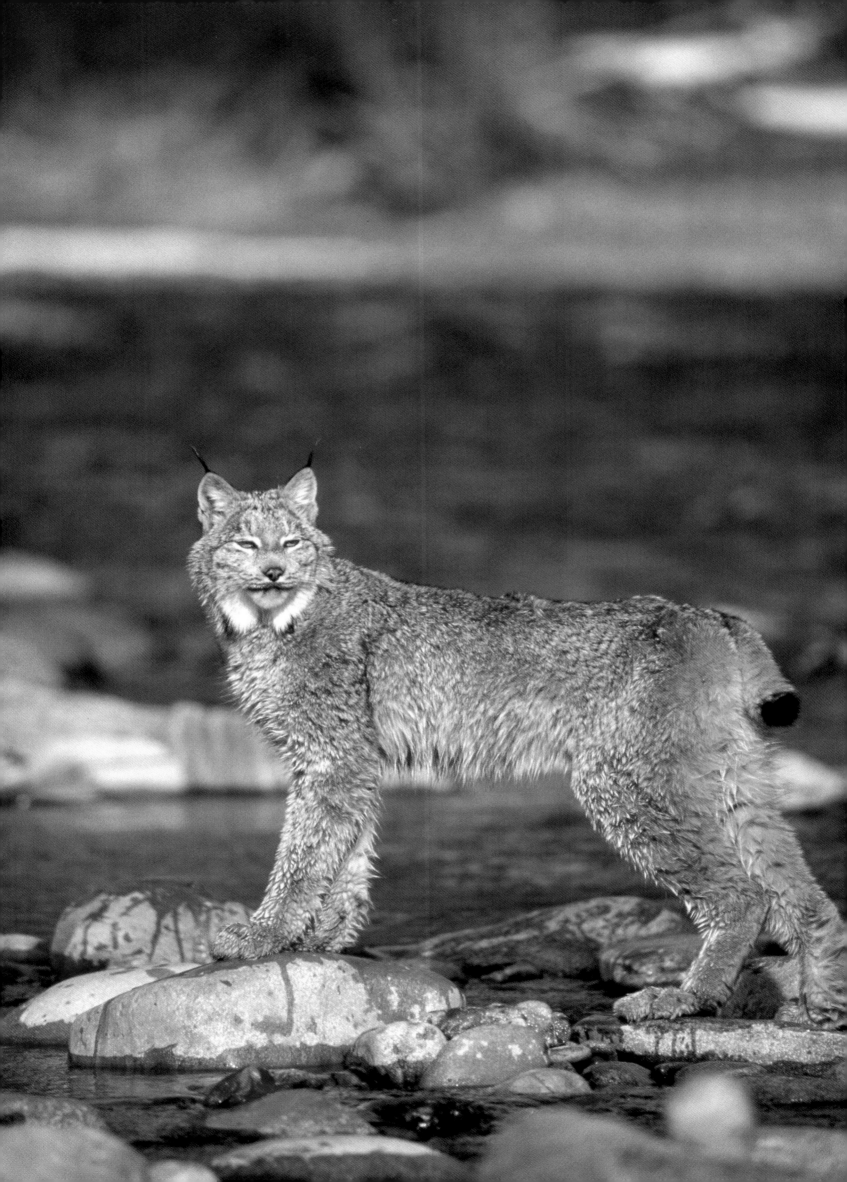

INDEX

*Page numbers in **bold-face** type indicate photo captions.*